AMERICA'S NEXT top model®

fierce guide to life

The Ultimate Source of Beauty, Fashion, and Model Behavior

By JE Bright

AMERICA'S NEXT
top model®

fierce guide to life

The Ultimate Source of Beauty, Fashion, and Model Behavior

universe

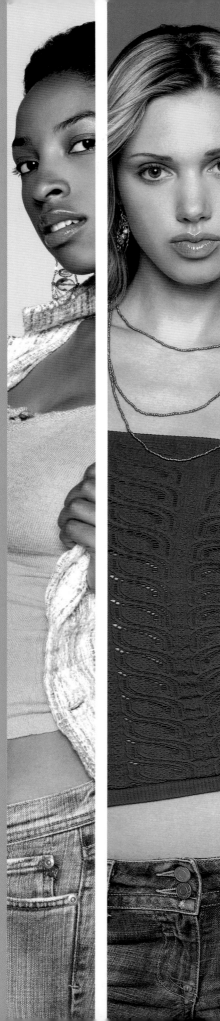

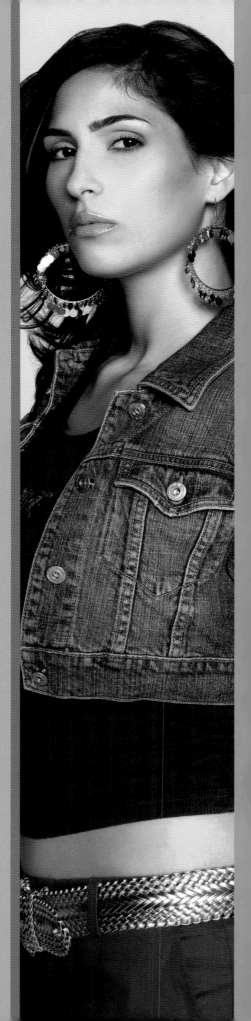

This edition first published in 2009
by UNIVERSE PUBLISHING
A division of Rizzoli International
Publications, Inc.
300 Park Avenue South
New York, NY 10010
www.rizzoliusa.com

2009 2010 2011 2012 / 10 9 8 7 6 5 4 3 2 1
First Edition

Printed in China

ISBN-13: 978-0789318596
Library of Congress Control Number:
2008938646

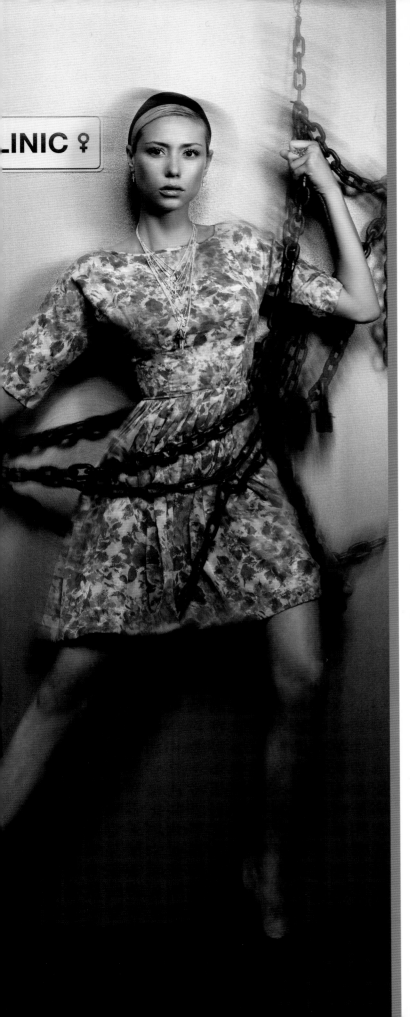
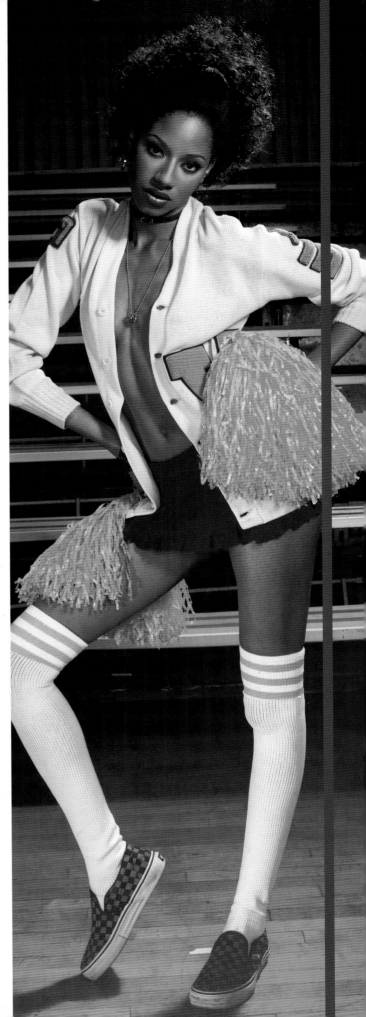

Table of Contents

Table of Contents

You want to be on top?

That is, do you want to be a top model in the lucrative and highly competitive — even cutthroat — high-fashion or commercial modeling industry, like the contestants on ***America's Next Top Model*** or just look like one?

If you know you've got what it takes to succeed, this book can offer you tips on maximizing your beauty potential, finessing your fashion acumen, polishing your skills, and navigating the business of modeling.

Simply dreaming about becoming a model is not enough. The work requires an enormous amount of determination, persistence, and stamina . . . as well as a commitment to beauty that goes above and beyond the usual standards of attractiveness.

There's a long list of difficult requirements to become a success. If you can handle rejection and stress, sustain your self-confidence, maintain a level of emotional stability, say "no" to drugs and late partying, always look your best even in the early morning, discipline yourself to maintain a healthy mind and body, sustain a clear complexion, be wiling to change your look — including the color and cut of your hair — keep up with the fashion trends, take direction from photographers and stylists, release your inner extrovert, emote well for the camera, rely on your visual talents, keep your teeth sparkling white, and your mind focused on a pure determination to succeed, then you have a good chance of making it.

All that you're missing now is the right mix of healthy beauty tips, honed modeling skills, an understanding of the fashion industry, business smarts, and a positive attitude. That's where this book can help.

Get ready to let your fierce inner diva shine!

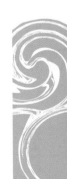

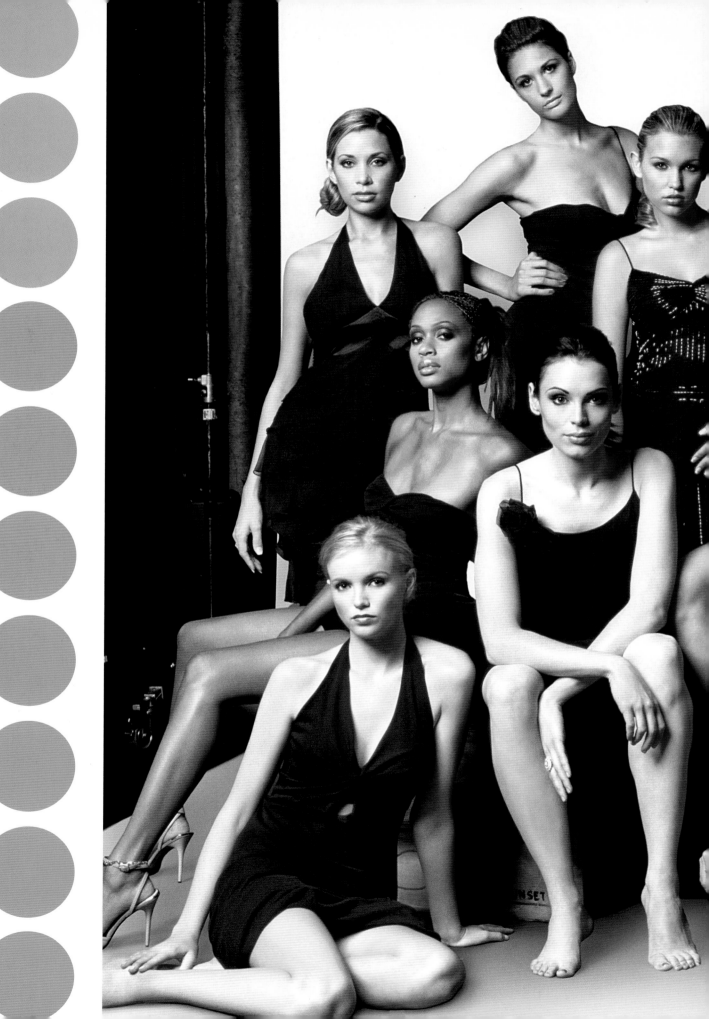

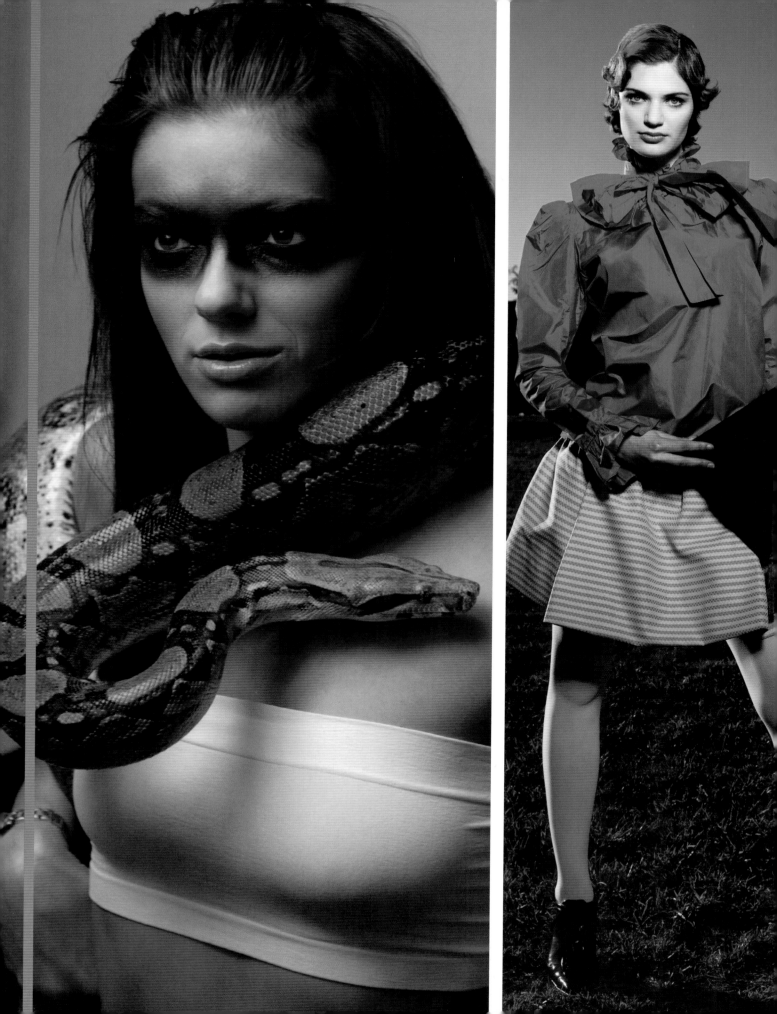

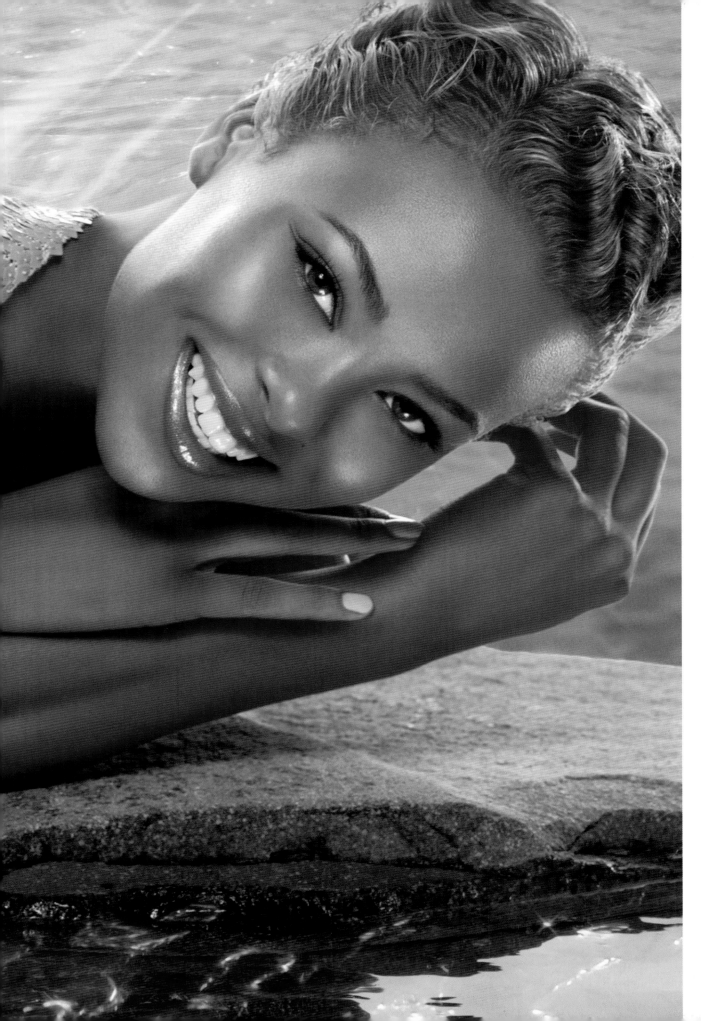

Do you wish you had been born beautiful? For the lucky (or deluded) one or two of you who answered that question, "Well, I know I was," you may think you could skip this whole beauty section. Bye-bye! (Actually, wait! It would be better for the born-beautiful to keep reading if just for the reality check.)

The rest of us will continue reading and consider this pearl of wisdom from *America's Next Top Model*:

Beauty is something you create, not something you're born with.

Beauty takes work. Even if you won the genetic lottery at birth and were gifted with a naturally gorgeous face and body, those advantages would only be the raw material that might make your journey to beauty easier. We all know people who are physically attractive, but whose ugliness glares out from their insides. And we all know people who might not fit within normal standards of prettiness, but who shine with an inner light and strong personal style that make them surprisingly, sometimes shockingly beautiful. Beauty takes a determined effort toward improving not just your appearance, but your heart, mind, and soul, as well.

True, it helps to have been born with classically pretty, symmetrical features, but your overall physical health, makeup, grooming, style, and most of all your confident attitude can transform even the most unfortunate genetic mishaps into unique and striking features that you can make work for you.

While a certain level of well-proportioned symmetry in the face and body has always been in style, please remember that many aspects of beauty are cultural, meaning that they have changed over time and according to place. The true beauties of world history redefined the meaning of loveliness and created a new beauty standard for their culture. But none of those people did so accidentally. It was a combined force of personality and a willingness to embrace themselves completely that blazed a new trail of beauty.

Don't forget that it is beautiful to be human — perfect is boring. Turn your negatives into positives by embracing them, overcoming them, or learning how to minimize their appearance by improving your posture; utilizing posing cheats; adapting your makeup, clothing, and specific hairstyle; or promoting sheer unadulterated attitude that comes from the deep truth of who you are.

We are all born with the ability to be beautiful. Let your beauty not only shine . . . make it glow.

Everyone has the inner potential to be beautiful, but that said, beauty in real life and beauty in the modeling industry are two totally different things. Everyone is welcome to use the advice on accentuating personal beauty in the sections that follow this chapter, but the requirements of modeling are specific, and some of the tips and suggestions are geared toward the needs of models.

Remember, modeling is about using your beauty to sell a product. That means that the fashion, manufacturing, and advertising industries choose models who they believe will tell a story with their look and make the most people identify with the image in order to get them to buy more goods. A commercial standard of beauty is what is necessary for models to achieve and maintain. You could be a world-class beauty and still not have the exact look needed to sell a range of products. And different merchandise has different needs and standards. In fact, some of the most successful models are not classically beautiful, but some aspect of their look translates as "model" to the camera.

High Fashion

To start a career in high-fashion modeling, you should be between 15 and 22 years of age, although the younger, the better. Most models don't have long careers, so modeling agencies prefer to invest their time in someone young. The fashion industry can be cutthroat — often when the first signs of age appear, they're like, "Next!"

You should be slim, tall, and have almost exaggeratedly long legs. The minimum height is almost always 5'8", with a height ceiling of under 6', although there are some slight exceptions.

If you are a tiny bit shorter than necessary, always wear high-heel shoes — practically sleep with them on! And compensate by being intensely striking.

The average weight for a fashion model is less than 120 pounds. This skinny, tall body type looks best in runway clothes, and a model must fit into designers' sample clothing which is specifically intended for thin women. Since it's often said that a camera adds 15 pounds, a scrawnier body photographs most appropriately for fashion, and shows off the high-end designs to their best advantage.

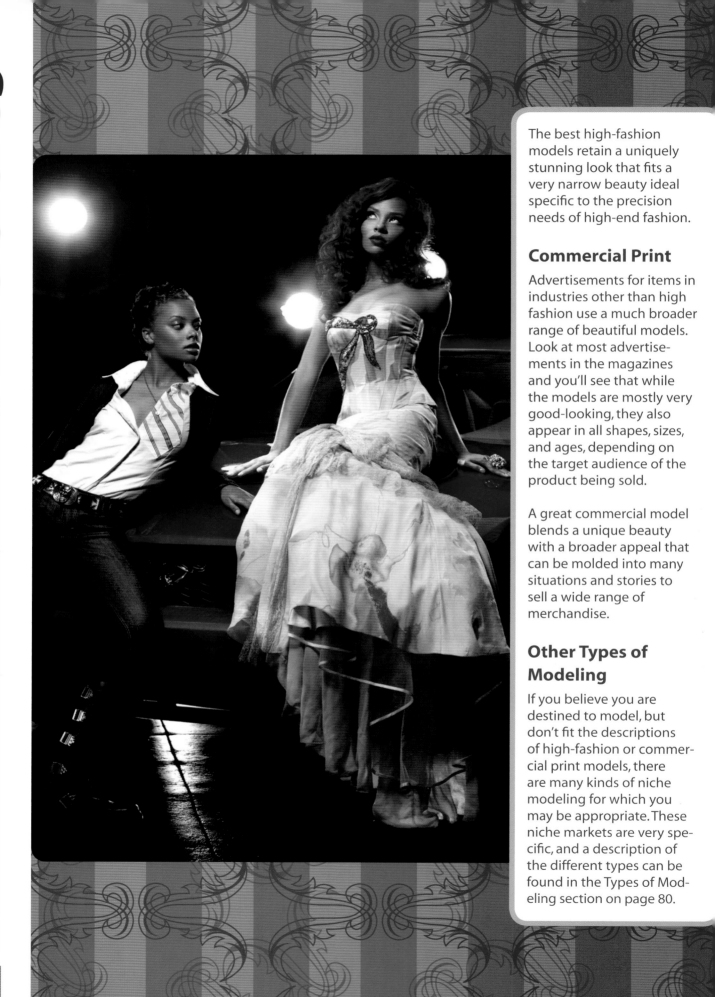

The best high-fashion models retain a uniquely stunning look that fits a very narrow beauty ideal specific to the precision needs of high-end fashion.

Commercial Print

Advertisements for items in industries other than high fashion use a much broader range of beautiful models. Look at most advertisements in the magazines and you'll see that while the models are mostly very good-looking, they also appear in all shapes, sizes, and ages, depending on the target audience of the product being sold.

A great commercial model blends a unique beauty with a broader appeal that can be molded into many situations and stories to sell a wide range of merchandise.

Other Types of Modeling

If you believe you are destined to model, but don't fit the descriptions of high-fashion or commercial print models, there are many kinds of niche modeling for which you may be appropriate. These niche markets are very specific, and a description of the different types can be found in the Types of Modeling section on page 80.

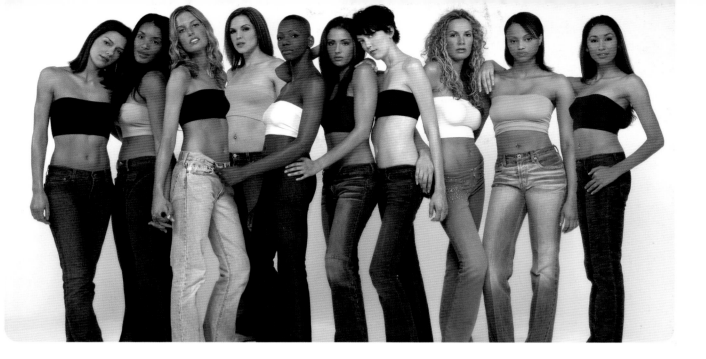

Many definitions of beauty suggest that the appearance of radiant health is what makes you beautiful. To the poet John Keats, "Beauty is truth, truth beauty," but to advertisers, health is beauty. When looking through magazines or watching television, you have to realize that ads are often designed to communicate the story of a healthy woman to potential buyers — an image of happiness and physical wellness associated with the product.

Projecting an image of glowing health is crucial to breaking into the modeling industry, and keeping to a healthy diet and program of regular exercise is the only way to maintain that image. Once models break into the industry, success is only achieved by sustaining their habits of eating healthily and working out consistently.

Making these healthful habits a part of your life will not only improve your natural beauty, but they will also improve your self-confidence and elevate your mood, which adds enormously to your overall gorgeousness.

Action Heroine

Being a model is often extremely stressful and physically challenging, requiring hours of intense focus, energy, determination, and a willing attitude, so being in shape helps you handle the demands of the job. You can think of modeling in a similar way to being an actor in an action movie, or a professional athlete — modeling is a physical activity, and your face, body, and physical presence are your main tools of the trade.

New High-Fashion Health Guidelines and Laws

While the high-fashion standard of the size zero still deeply influences the runway and fashion magazine layouts, many concerned countries and style mavens around the world are realizing the overall impact of superskinny models. The nearly unachievable scrawny standard affects not only models in the industry, but also the health of everyone who follows fashion, and young women's perceptions of themselves. The tide is turning on the belief that starving stick figures are the only standard of beauty.

New laws have been passed by the fashion industries of Spain, Italy, France, and the United Kingdom, among other countries, requiring that all models in runway shows have a doctor-certified Body Mass Index (BMI) of at least 18.

In America, the CFDA (Council of Fashion Designers of America) has released a set of guidelines called the CFDA Health Initiative. These guidelines suggest that models who have been diagnosed with eating disorders get professional help before they're allowed to continue working. Other recommendations from the CFDA include avoiding hiring models under 16 years of age. Other bans on underage modeling work include forbidding models under 18 from working overtime. They also suggest that designers create their clothes in bigger sample sizes, provide healthier food and beverages at fashion shows, give more rest breaks to working models, and ban smoking and alcohol consumption in the workplace.

All of this reform stems from the realization that fashion influences the standards of beauty, and if models are unhealthy, they'll look unhealthy when they really should inspire young women to radiate robust well-being instead.

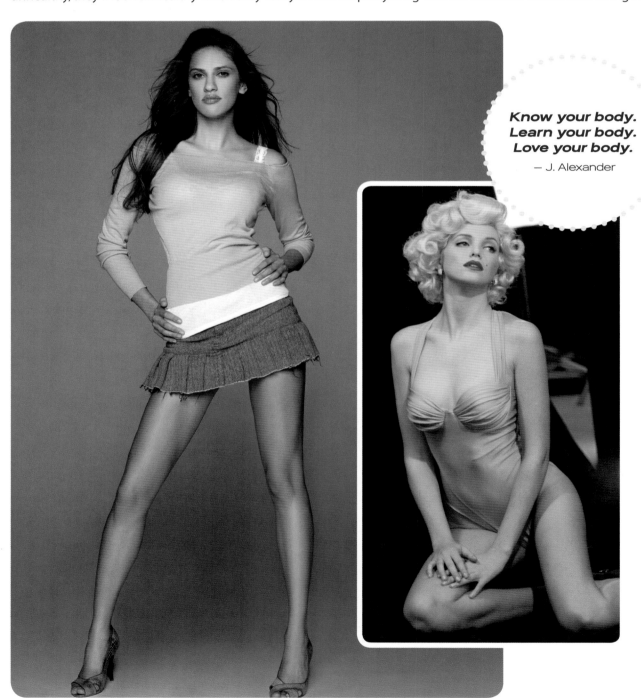

Know your body.
Learn your body.
Love your body.
— J. Alexander

The single most important non physical thing you can do to make yourself more beautiful is work on your sense of self-confidence. Nothing is more appealing than poise and a steady and relaxed aura of calm composure. Truly, confidence defines *cool*.

Everyone suffers from some degree of insecurity, no matter how beautiful and confident they're considered by the rest of the world. The trick is to learn how to mask your insecurity, to present a self-assured facade no matter how much you're trembling inside. Show your strength. Dominate the room with your certainty. Even some arrogant swagger is appreciated, as long as it doesn't tip over into being obnoxious.

Of course, presenting that cool face and strong body language is a lot easier if you're not trembling inside. So much of insecurity comes from not accepting our bodies and ourselves for what we truly are. Believe in yourself and trust in your beauty, on a deep, internal level. Nobody is saying that this kind of core belief is easy. It can only come from within yourself, from your own foundation, not from any outside reinforcement. It's the essential basis for beauty.

Everyone has seen the young woman who enters the dance club with her head held high, believing that she's the finest girl in the room. She may not have all the assets that anyone may objectively consider beautiful, but it's because of the confidence she has in herself that all the guys swarm around her. You have to learn to carry that girl around inside yourself, always knowing you look great, even if you don't feel it that day — especially if you don't feel it that day.

Life can be harsh. When you get rejected, it's difficult to separate yourself from the dismissal, but remember that everyone suffers from insecurity due to rejections — even models at the top of the profession. Learning how to handle rejection is a crucial task. Don't fish for compliments — it just reads as insecurity. Avoid getting depressed or down on yourself by continuing to reaffirm your core belief in yourself. It also helps to discuss your feelings with someone you trust.

Inner Beauty

Inner beauty comes from your essential self — your personal, private center of love, kindness, compassion, and strength — where you always know that you have a beautiful soul. Contacting this centered place within yourself will help you recognize the destructive power of your own negative judgments about yourself, as well as help you ignore the outside damaging opinions of others that may wear on your inner beauty.

Inner beauty requires you to be vulnerable so you can recognize the joyful truth about your central self. Find your unique gifts and develop them so you feel a deep personal sense of self-satisfaction. When you feel satisfaction in your passions, and use them in a positive way, your inner beauty will radiate to your outer self until you glow.

Treat Yourself

When your schedule gets hectic, clear some time to put yourself first for tender loving care. Learn how to say "no" politely to over-whelming demands and pamper yourself with personal, private relaxation.

Play

It's often said that the best way to be successful in your work is to think of it as play, but it's equally important to reserve some time to explore hobbies that have nothing to do with your job. Forget about modeling for a while and do something else you truly enjoy without any guilt.

Breathe

Stress often makes you forget to breathe deeply, thereby breaking the link of breath between your body and the outside world. Taking a moment to inhale and exhale deeply pauses the rush of events and allows you to relax and center yourself properly.

Meditate

Take ten minutes out of your busy schedule to sit quietly with no music, no distractions, and no interruptions and simply try to clear your mind. Don't fret if busy thoughts crowd your brain . . . just return to a quiet mind. Spending this time alone with your silent self will help you develop a sense of inner peace.

Smile

Tension clenches the face and furrows your brow. Remind yourself

to put on a big grin whenever you feel stress creeping up. A smile loosens your facial muscles and relieves anxiety throughout your body, releasing endorphins. Besides, in the proper situations, a smile relieves the stress of those around you, too.

Take a Bath

Allow yourself the time for a soak in the bathtub with no distractions. Besides the obvious cleaning benefits, a warm bath is deeply relaxing and removes you from the hectic pace of daily life. Don't forget to add bath salts and aromatherapy oils to the water, which flush out toxins from your skin and can help to elevate your mood.

Perform a Random Act of Kindness

Take the time to help others, even if it's just holding the door for someone, giving up your taxi for someone in a hurry, or giving a flower to a stranger. Little kindnesses raise your spirits along with those of the person you've helped. Bigger ways to serve your fellow humans, such as reading to the elderly or volunteering in a homeless shelter, provide deep satisfaction.

Remember that life is a journey. No matter how fast life comes at you, don't forget to stop for a second, look around, and enjoy the ride. So much of life is barreling ahead toward the next goal, but the steps to get there, the process, is equally important and should be savored.

Treat your body with the utmost respect. Yes, the attractiveness of your face is important, but always remember that it's your body that's selling the clothing you're wearing.

HELPFUL HINTS:

Smart Style

Yes, you should fully embrace your body, with all of its flaws, but it also doesn't hurt to consider a little clothing camouflage either. The savvy model knows how to dress herself to accentuate her positive body aspects and minimize the negative ones. Never forget that the clothing that you feel sexiest in is also the style that lets you carry yourself most confidently.

Besides a healthy diet and a consistent exercise regime, the keys to presenting a physique that looks fabulous in any outfit include a positive body image and a smart sense of style.

Body Image

The way you imagine yourself in your mind is your body image. That imaginary picture is a mixture of your own memories, fears, hopes, assumptions, and past reactions to compliments and insults, blended with the truth you can see in mirrors and photographs. It affects how you think about your body, even changing the way you control your physical self as you move around. It's a measure of how you feel about being *within* yourself, not simply how you feel about your actual body's shape.

Due to strict societal pressures to conform, negative body image has become a widespread epidemic among many young women. These women see part of their body as being different from how they really are. They develop a terrible anxiousness and shame about their bodies. The result is a physical awkwardness that is poison for any modeling career.

To avoid falling into the trap of negative body image, you must celebrate and appreciate your natural body shape while striving to reach your best potential in a healthy way. Always remember that your body is not truly representative of your character or personal values, even while you're selling that image to the audience. Reaffirm your own sense of your beautiful body and overpower any negative images, until you once again feel comfortable enough to fiercely strut your stuff.

Too Big

Get back in black! Dark clothing creates an illusion of slimness. Certainly steer clear of loud prints which only accentuate extra surface area. Make sure your clothes aren't too tight or too baggy — a properly fitted, supportive garment will show off your sexy curves without being too revealing.

Too Short

Clothes that are either too baggy or long will make you look like you're even shorter — make sure that your wardrobe is well-fitted. To make your legs seem longer, try a shorter shirt. It also helps to unify your whole outfit with a single color so you don't look broken up by blocks of color.

Too Tall

It's rare to have legs that are too long, but if you must minimize their length, longer shirts and high boots will make your legs shrink. Horizontal stripes, and defined color boundaries between your top and bottom, can also help break up your towering appearance.

Too Flat

If you're lacking a little on top and want to increase your bust, there are other tricks you can use aside from putting on a padded bra. Simply adding layers like an undershirt will add fullness to your breasts. Find shirts with pockets or detailing on the chest to suggest a more pronounced appearance while wearing a fitted shirt. Avoid low, deep necklines, and instead choose a boatneck, jewelneck, or sweetheart-style collar.

Too Busty

Make sure your bra is giving you the proper support and not squashing your breasts, which will only draw attention to them. Tops should be roomy, with a V-neck or open collar. Longer sleeves will move the focus away from your large bust.

Too Hippy

Wideness in the hips can be minimized by wearing a pant that falls straight down, rather than anything that hugs the legs too snugly. Steer clear of pockets or any detailing in the hip area, and patterned pants in general should be shunned. Stick to dark, solid colors for your lower half and a gentle pattern or lighter colors for your top in order to draw the eye upward. Avoid pleated pants like the plague!

Plus-size

The qualities you need to look like a plus-size model (also known as a "full-figure model") are nearly the same as those who aspire to look like any commercial or high-fashion model, with one main difference: you have larger measurements around the waist, hips, and bust.

Full-figure models are toned and proportional, with a lovely hourglass shape. You must fit a dress size 10 to 18 (although many agencies now consider any model over the size of 6 plus-size). The height requirements are the same as they are for typical models: 5'8" to 5'11". Your skin, teeth, and attitude must be perfect, as a plus-size model is often judged on the beauty of her face and smile, along with the intensity of her positive personality.

In the high-fashion and commercial clothing industries, full-figure models mostly work showing clothes that are specifically designed to be sold to plus-size women. Recently, however, thanks to some relaxation in the standards of beauty, and more of a cultural acceptance of the reality that women come in all sizes, full-figure models have branched out into other kinds of commercial modeling, selling products not exclusively aimed at larger women.

Because full-figure models represent the interests of "regular" women, you are often called upon to look wholesome and beautiful in a conservative way. Tattoos and piercings are frowned upon on full-figure models even more than they are for typical models. There has yet to be a plus-size model who has broken through with an edgy look.

Whitney Thompson was the first full-figure competitor on *America's Next Top Model* to win. She maintained a dress size of 10 throughout the cycle.

"The thing that makes me different from the other plus-size models is [that] I'm not just going in saying, "I'm really pretty, and I don't want to diet, so I'm going to be a plus-size model," Whitney explained. "That's not my mentality at all. I'm saying I'm here to change things so that little girls have someone to look up to. I'm here to fight the eating-disorder battle that millions of people are having and I'm standing up and saying that's not okay. I don't have to starve. I don't have to have plastic surgery. I can be on the billboard. I can be on that magazine cover. Why? Because I'm beautiful — on the inside and out. I have breasts, I have hips, I have a butt — and I am so proud of those things."

Skinniness may be the norm for models, but everyone should do their best to be in shape and have a well-proportioned body. All successful models adhere to a strict diet — being so disciplined is their job. The trick, for the rest of us, is to diet in a healthy way and take care of yourself. A good diet should raise your spirits, not make you miserable.

Portion control is one of the keys to losing weight. Eat small, well-balanced, and low-calorie meals at regular times, three to five times a day, depending on your personal metabolism. Don't eat until you feel full and don't snack between meals. Skipping meals won't help as your metabolism will slow down and you'll actually gain weight.

What you eat is crucial, of course. Make sure to eat foods that supply the necessary vitamins, minerals, fats, and carbohydrates to maintain the shape of your body and keep your skin, hair, nails, and digestive system healthy. A balanced diet will supply you with the energy you need for the hard work and often long hours of modeling.

Stick to organic foods, eating at least five portions of raw fruits and vegetables per day, including fresh juices and smoothies.

When cooking, try to prepare your meals using grilled or steamed vegetables along with broiled, roasted, or baked lean meats, such as fish and chicken. Avoid red meats.

Stay away from all canned and processed junk food with too much salt, sugar, fats, refined flour, chemicals, or preservatives. Don't eat anything with high-fructose corn syrup as an ingredient if you can help it!

Don't believe all the rumors you hear about incredible fad diets. They can drastically harm your health, as well as cause your

energy level to plummet, which will affect your ability to model. The fad diets don't work anyway, because as soon as you stop the diet, you'll go back to overeating. Regular, healthy eating is a much more successful and sustainable method for maintaining a beautiful, slim body.

If you do find your health failing because of an unwise diet or an eating disorder, consult a health professional immediately.

HELPFUL HINTS:

Tips for Thinking Thin

- Keep a diary about everything you eat.
- Don't skip breakfast!
- Find a diet buddy so you can support each other.
- Tape a skinny picture of yourself on the refrigerator door.
- Only keep healthy foods in the house.
- Keep cut vegetables in the fridge for when you must snack.
- Use mustard as a sandwich spread, never mayonnaise.
- Don't confuse thirst for hunger — stay hydrated!
- Drink a glass of water before eating.
- Eat slowly and savor each small meal.
- Never fry your food.
- In restaurants, order healthy appetizers instead of an entrée.
- Skip sauces on your foods.
- Don't drink your calories — stick to water and zero-calorie beverages.
- Avoid alcohol.
- Only buy foods from a strict shopping list.
- Bring a protein bar or carrot sticks whenever you leave the house.

Drinking water helps keep you beautiful. Our bodies are made up of more than 70% water, so drinking enough water is a vital part of maintaining your physical health. It's crucial for weight loss, too. Water facilitates fat metabolism in your body and eliminates waste and toxins, flushing out your system. It also makes you feel more full, reducing your hunger, which you can sometimes feel even though you're actually thirsty. Usually eight glasses of water is the recommended amount for you to drink daily.

Stick with drinking pure water whenever possible. It has no calories, no sugar, no fat, and no carbohydrates — the perfect health drink. Many models swear by zero-calorie sodas and coffee, but it's best to avoid all caffeinated beverages if you can — they act as diuretics and possibly lead to dehydration.

Many people suffer from dehydration after an intense workout or after posing all day under hot lights. The initial symptoms of dehydration are weakness and a loss of alertness, followed by diziness, headaches, thirst, blurred or double vision, and fainting. Eventually, your entire body may shut down. Always bring water with you and drink it constantly during your workout or photo shoot.

If you're in the hot sun or a humid area, you'll dry out a lot faster, so don't forget to increase your water intake significantly. Try to drink cool water as the stomach absorbs it more quickly, and during exercise or hard work, it has the added effect of reducing your internal body temperature. Research that suggests that drinking cold water may help weight loss, since your body burns a few calories as it warms the water.

Water is wonderful for your complexion, too, cleaning out the toxins that can dull its glow and clearing your skin. Staying hydrated will keep your skin youthful-looking; when your skin dries out, it loses elasticity and wrinkles easily. Dry skin is also more susceptible to damage from the sun or smoke.

Develop good water drinking habits. Have a glass of water when you wake up, before and after every meal, before and after exercising, and before you go to sleep. Carry a water bottle with you everywhere and drink from it all day long.

A big part of your personal and professional responsibility is to keep yourself fit and healthy, and along with dieting, that means exercising regularly. A healthy exercise routine is crucial for you to maintain your appearance, skin tone, stamina, energy level, and confidence. Choose a kind of workout that you truly enjoy so you can sustain it as a permanent part of your daily life. Committing to staying in shape is a decision that changes your whole lifestyle — it's not just an hour a week at the gym — so make it fun!

Types of Workouts

You'll probably want to exercise to tone up your body and keep it slim, not to build muscle. Don't become buff — unless you want to be a fitness model!

Cardio

Doing cardio, which is short for cardiovascular exercise, means that you're involved in an aerobic (oxygen-using) activity of medium intensity that raises your heart rate to a sustained higher level for an extended period of time. Nothing will keep your body toned and fit like proper cardio exercise. Cardio exercise is also great for releasing stress, and it can help you project sexiness.

There are many different types of cardio exercises. Some of the most popular include swimming, running and walking (on the streets, tracks, or treadmills), aerobics, dancing, and martial arts. Other cardio exercises that have a lower impact on your joints are rollerblading, using the elliptical machine, skiing, and cycling or indoor stationary cycling.

The optimum amount of time for your cardio workouts would be a half-hour to an hour of exercise five or six times a week, but if you don't have that kind of time (and who does?), any amount of cardio exercise daily helps significantly. It's often best to do your cardio first thing in the morning before breakfast, or right after a strength-training workout.

Strength Training

Strength training is a type of workout that uses weight training (using the gravity of weights) or resistance training (using the resistance of bendable or stretchable material) to stimulate muscle contraction and growth. An intensive strength-training session also keeps your metabolism raised after a workout, sometimes for days afterward, which continues to burn fat and calories. Strength training is great for reshaping problem areas of your body and creating a more symmetrical figure, but be careful not to bulk up your muscles too much!

Yoga and Pilates

Although they stem from different disciplines, both yoga and Pilates are centered on the connection between your mind and your body, focusing on sustaining stretching poses and breathing control. Practicing either discipline is an excellent way to lose weight, since they both develop your muscle tone and increase your metabolism in the long term, as well as burning calories immediately. They're also often more fun than gym workouts, and can be quite relaxing. Many models swear by yoga and Pilates, especially because holding the exercise poses is great practice for posing for a camera or on the runway.

HELPFUL HINTS:

Easy Exercises Tips

- Always stretch your body before working out.

- Walk up the stairs rather than take the elevator.

- Vary your exercise routines so you don't get bored.

- Reward yourself for going to the gym — but not with food.

- Wear comfortable clothing while working out.

- Join a cardio gym class to get professional input and stay on a schedule.

- Exercise with a friend to make it a social event rather than a chore.

- Listen to your favorite music when exercising.

- Walk or ride your bicycle to the store rather than drive.

- Join a sports team.

- Tone your arms with light weights while watching TV.

- Park your car further away from your workplace.

- Track your exercise efforts in a daily diary.

- Take your dog for a long walk.

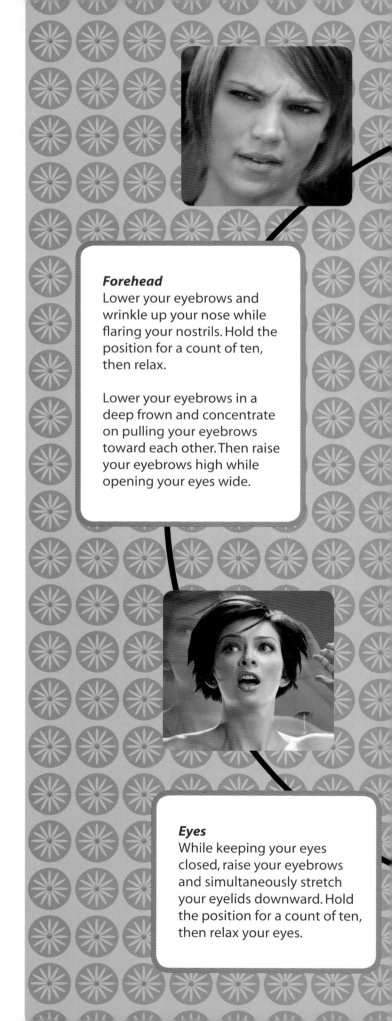

Forehead
Lower your eyebrows and wrinkle up your nose while flaring your nostrils. Hold the position for a count of ten, then relax.

Lower your eyebrows in a deep frown and concentrate on pulling your eyebrows toward each other. Then raise your eyebrows high while opening your eyes wide.

Eyes
While keeping your eyes closed, raise your eyebrows and simultaneously stretch your eyelids downward. Hold the position for a count of ten, then relax your eyes.

Lips

Pucker your lips and raise them towards your nose. Hold the position for a count of five, then relax your lips.

Pucker your lips and then relax them, pulling them into your mouth, curling your lips across your teeth. Hold the position for a count of ten, then relax your mouth.

Cheeks

Using your cheek muscles, pucker and pout your lips while keeping your mouth closed and relaxed. Hold the position for a count of ten, then relax your cheeks.

Facial Exercises

Exercise is not just for your body! Tone up your facial muscles, which will help smooth out wrinkles, tighten saggy or puffy skin, and prepare your face for all the fierce modeling expressions you have to hold for the camera.

Neck and Throat

Look up at the ceiling while keeping your lips closed and move your jaw in a chewing motion.

Look up at the ceiling and pucker your lips, stretching them as though you're trying to kiss the ceiling. Hold the position for a count of ten, then relax your mouth.

Extreme beauty shots, like those taken for class pictures or advertising, are all about your gorgeous face, and your skin needs to be flawless for those unforgiving close-ups. Retouching photographs is expensive, so stunning skin is absolutely crucial! Beautiful skin is not simply clear of blemishes — a smooth, radiant skin texture is equally important. So beware of anything that dulls your skin color, or makes your skin too dry, rough, or oily.

I can tell she tans a lot, and I can tell the skin on her face is starting to get a little leathery.

— Douglas Bizarro

Avoid the Sun

Protect your skin from that big ball of fire up in the sky! Sunlight wrecks your skin, causing wrinkles, dry patches, messed-up coloration, liver spots, and tumors. Stay out of direct sunlight during peak hours — from 10 a.m. to 4 p.m. If you must go out on a sunshiny day, don't forget to wear a wide-brimmed hat, and sunglasses so you don't squint. Always, always wear sunscreen with a sun protection factor (SPF) greater than 15. Put sunscreen on 20 minutes before going outside and reapply every two hours.

Don't Smoke!

Smoking is awful for the skin. It stops blood from flowing properly to your skin cells, stealing its oxygen and nutrients. Also, those dorky faces you make when smoking — sucking on the cig and squinting from the smoke — can give you wrinkles around your mouth and eyes.

Smoking cuts your skin career in half.
— Iman

Clean Your Face Gently

Keep your skin as clean as you can . . . but don't forget to treat it gently! Hot water removes oils, drying you out. Don't take baths or showers longer than 15 minutes, and use warm water — not hot! Stay away from strong soaps, which strip oil and leave your skin dry. Use mild, scent-free soap, without irritating ingredients. Always remove eye makeup carefully, using a soft sponge or cotton balls so you don't damage the delicate areas. If you wear waterproof makeup, you can use a gentle oil-base product to remove it. After washing your skin, pat it dry with a towel so you don't rough it up.

Moisturize, Moisturize, Moisturize!

Moisturizers work by keeping some water from escaping from your skin — or by slowly releasing water into your pores — to maintain a healthy, smooth glow. Test if you need to moisturize by waiting 20 minutes after washing. If your skin feels tight, you should moisturize. Choose a moisturizer with an SPF greater than 15 so that your face is always protected from the sun. And remember to moisturize before you apply makeup!

Makeup

Y ou don't necessarily need to wear makeup to be beautiful, but using it well can take you to the next level of beauty. It can accentuate your cheekbones, minimize the width of your face, make your skin more evenly toned, lessen the impact of a larger nose, make your jaw more or less prominent, cover blemishes, and add fullness to your lips.

Makeup can also draw attention to your best features, making your beautiful eyes stand out brightly with eyeliner, eye shadow, and mascara; centering the focus on your lips; or accentuating the blush in your cheeks.

Wearing makeup is also a great way to express your own personal style. It's important to start by finding a personal foundation color and powder that most closely matches your natural skin tone, and then adding flourishes to your features to complement your clothing choices and communicate your personality with color. Don't overdo makeup, though — a little goes a long way, and too much can easily make you look loud or cheap. Never match your eye shadow to your gown!

Like a model, you'll need to be able to do your own makeup in your daily life, when you're at social events, meeting with clients and designers, and in situations when there isn't time to have a cosmetics stylist complete your look or when no stylist is available. The most important time for your own makeup to be flawless is when you're applying for a new job and you must impress them with your look and style so they hire you.

flawlessly gorgeous

Day and Night

The difference between day and night makeup has nothing to do with the clock, and everything to do with the lighting you'll be under. The fluorescent light of offices read as blue light, which makes all colors under it look sharper. Bright sunlight and fluorescents make everything appear more clearly, and so sheer, natural, and neutral cosmetics are necessary so that you don't look like a clown.

Incandescent light, the light most often used on photo shoots, in private homes, and at evening parties, has yellow or red tones that tend to soften all colors. Under incandescent lighting, which is more forgiving of imperfections, use slightly brighter and bolder cosmetic colors to add more contrast to your face.

For dimly lit places such as nightclubs, wear significantly more makeup in bolder styles so that you stand out in the dark. You should also wear heavier, more dramatic makeup when you're going to be under bright stage or set lights, which wash out your features.

Usually ugly women put on a lot of makeup

— Carmen Marc Valvo

Basics of Applying Makeup

1. Clean your face and neck with a cream-base cleanser.

2. Apply a water-base moisturizer.

3. Dab concealer onto blemishes or imperfections. Use a yellow-base concealer in a color about three shades lighter than your skin color. The same concealer can be used to lighten the dark area under your eyes, and smooth out problem areas around your mouth.

4. Find a foundation makeup that exactly matches your skin color. Test it to make sure that the color blends into your skin — it should look like you're wearing no foundation at all. Make sure it doesn't look too pink or orange, which often looks fake. Spread the foundation evenly over your face and neck. The foundation on your face and neck should match with the coloring of your upper chest, or the line where you stopped will be apparent to other people and be picked up by the camera.

5. Apply the same color powder as your foundation to create a matte finish. Use powder in a shade lighter under your eyes to help lighten dark circles.

To create an oval look for your face, apply powder in a shade darker to your cheekbones and under your chin. Don't forget to blend it in so that no distinct lines are created.

6. Apply blush in a color darker than your foundation, which can soften your features and give you a sensual look. When using powder blush, start your brush at your earlobe and sweep down your cheekbone to the apple of your cheek. A lighter color blush can also be used along with the darker blush to create dramatic highlights. Experiment with colors that work best for you, without looking overdone.

7. For a smooth look free from shine, add a light sweep of translucent powder.

8. Apply your eye makeup, starting with eye shadow, then eyeliner, and finally mascara. More specific eye makeup tips can be found starting on page 38.

9. Apply lipstick using a lip brush. If you must use lip liner, use the same shade as your lipstick, or one that compliments the color of your lipstick. More specific lip makeup tips can be found on page 45.

Photo Shoots and Events

If you're in charge of your own makeup at a wedding or on a photo shoot, don't forget that lights will wash you out, and the heat from the lights can make you look shinier than usual, so wear full foundation, stronger colors for contrast, and don't forget to powder. You may feel as though you're wearing too much makeup, but your features will hold up under the lights.

If you know you'll be using a cosmetics stylist, arrive wearing no makeup. If you're wearing makeup when you arrive, you'll waste everyone's time removing it, and leave your skin irritated from the cleansing.

Bring several colors of lipstick and blush with you so you can choose a shade that works in any situation.

Even when a cosmetics stylist is available, don't forget to bring your own makeup with you. The stylist may not have the brands or colors that work best for you, and you can always politely suggest that they use yours. If you're doing your own makeup, you'll need your cosmetics with you to touch up your makeup and reapply powder frequently to reduce shine.

Your eyes are your most communicative feature and are among the first things that catch the attention of others. They're the windows to your emotions, thoughts, and personality, and as a model, your eyes are the most important tools for connecting through the camera to the audience. This means that you've got to be sure your whole look centers attention on the expression in your unforgettable eyes, and the most effective way to achieve this, aside from the intensity of your gorgeous gaze, is through beautiful eye makeup.

Eye Shadow

Whenever you apply your own eye makeup, begin with the eye shadow. Choose a color that complements the rest of your style and clothing without matching exactly, unless you want a really dramatic look. Use a light shade so that your eyes won't get swallowed up in darkness.

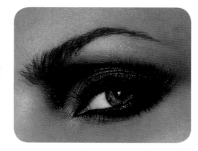

Applying Eye Shadow

1. Select a light base shadow in a neutral color like taupe or pearl. Sweep the base color with an eye-shadow brush across your entire lid, from your eyebrow to the line of your eyelashes.

2. Choose a complementary medium shade for your lower lids. Apply shadow up to the brow bone but don't apply directly on the bone.

3. Using a small eye-shadow brush, follow the crease of your eyelid with a complementary dark shade to highlight.

4. By stroking the lid gently with an eye-shadow brush, blend the three colors together smoothly. Avoid using your finger, which could wipe off the shadow or smudge it too much.

5. To tone down heavy eye shadow, press a clean cosmetic puff gently on your eyelid.

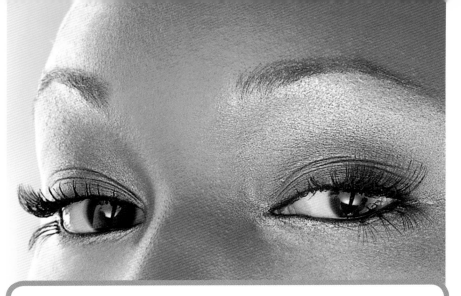

Shimmering, metallic eye shadow can make your eyes really stand out, but it can also make heavy lids, lines, and wrinkles much more obvious, so use it sparingly. Instead of the second medium-shade eye shadow, apply a streak of shimmer to the brow bone.

If you find your eye shadow smears or falls away after awhile, try starting with a primer-shadow base, which can help set eye shadow so that it lasts.

Eyeliner

After putting on eye shadow, apply your eyeliner, which can really frame the beauty of your eyes by providing contrast and making your eyes look larger and wider. You don't want the eyeliner to look too dark or obvious, though, or you'll look overdone, so use a light hand. Natural-looking eyes are often more desirable, so choose an eyeliner color that complements your eye color, and avoid black eyeliner unless you want a really bold, dramatic style.

Applying Eyeliner

1. In front of a mirror, pick up the eyeliner and close one eye. Don't hold your eye closed with your fingers or pull on the lid.

2. Place the tip of the eyeliner at the inner corner of your upper eyelid, and slide it toward the outer corner, drawing a smooth line as close to your eyelashes as possible. If you can't manage a full, straight line in one motion, it's okay to use short strokes. Draw the line thinner at the inner corner of the eye and thicker at the outer corner.

3. Place the eyeliner tip under the bottom lashes at the outer corner of the eye. Draw your second line along the eyelash line toward the inner corner, but again make sure the line is thicker at the outer corner, and thin when it reaches the inner corner.

4. For a softer look, smudge the lines gently with a small makeup brush or your fingertip.

5. Repeat the process with your other eye.

Eyelashes

Beautiful, volumized eyelashes intensify the drama of your eyes, and different mascaras can solve various eyelash issues, whether your problem is a lack of volume, curl, length, or definition, or any combination of the above.

Black mascara works best for almost everyone, but blondes should use a dark brown by day and only use black at night. Blue mascara can brighten blue eyes, while purple mascara can make brown eyes shine.

For even longer-appearing lashes, wiggle the mascara wand at the base of your lashes as you apply. The illusion of length comes from the mascara applied near the roots, not the tips.

To remove clumps, after applying mascara, close one eye and place the wand on top of your lashes at the base, brushing your lashes to loosen any bunching.

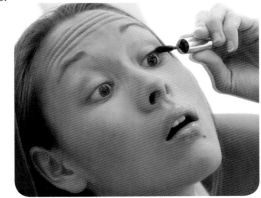

You can use an eyelash curler to make your eyes appear wider and brighter. Remember to use the curler before applying mascara, or wait until you're sure your mascara is completely dry. Warm up the curler with a hair dryer before using it to make it more effective.

Wait five seconds before blinking after mascara is applied.

False Eyelashes

An easy and very inexpensive way to lengthen your lashes is to use false eyelashes. But don't forget that your eyelashes are a minor part of your appearance, so don't go crazy with the fake eyelashes. You don't want them to look like giant spiders! Trim fake ones with small scissors before they're glued onto your eyelids, of course.

Eyelash Extensions

Recently, eyelash extensions have become popular and the process is now offered at many salons. The extensions are single strands of synthetic lashes that are curved to imitate a natural eyelash. They are applied to your individual eyelashes, one lash at a time. The procedure can be expensive, but if you often wear false eyelashes, it might be worth the cost.

Eye Size

One way to make your eyes look bigger and younger is to apply a thin line to the inner rims of your eyelashes with a white eyeliner. This line is hardly noticeable yet it can make your eyes appear much larger.

For wide-set eyes, apply a dark eye shadow around the inner corners of your eyelids and a lighter shadow at the outer corners. Use a dark eyeliner to draw a stroke only on the inner half of your eyelashes. Do the opposite to widen narrow-set eyes.

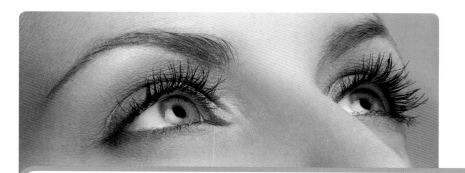

HELPFUL HINTS:

The Smoky Eye

One of the most popular and effective ways to achieve a sexy, nighttime look through makeup is with the infamous smoky eye — one of the longest-running styles in cosmetics and shows no signs of going out of fashion.

The standard smoky eye is created using heavy black, dark charcoal, gray, or brown colors, but deep hues of blues and purples and funky jewel tones can play up your eye color as well. It's important to pair the rich, dark shades with light base colors, such as taupe or pearl, and to choose a dark, complementary eyeliner to achieve the right look.

Applying the Smoky Eye

1. Spread an eye-shadow primer base across your entire eyelid. This will keep the natural oils of your skin from melting your makeup into your eyelid crease a few hours later.

2. Starting from the inside corner, draw a heavy line with your eyeliner on your upper lid very close to your lashes, with the line thickening over the middle of your eye.

3. Add eyeliner under your lower lashes, and smudge the line.

4. Sweep the light base color in your chosen color palette across your upper eyelid, from the lashes to the brow bone.

5. Apply your darker smoky eye-shadow shade from your lash line almost up to the crease of your eyelid.

6. Blend up. The secret to the perfect smoky eye is proper blending. The eyeliner should disappear into the smoky eye shadow, and the deep smoky color should fade past the crease of the eyelid.

7. For extra sparkle, dab a little sheer shimmer shadow onto your brow bone.

8. Add two coats of black mascara to really boost the smoky "oomph" factor.

Remember that when you're wearing heavy, dark eye makeup, you want to down-play the rest of your facial cosmetics. The smoky eye works well with light, flawless skin and pale blush. Keep your lip color relatively neutral, too.

Eye Puffiness

Wrinkles and puffiness often appear around and under eyes from drinking, smoking, lack of sleep, stress, water retention, allergies, hormonal changes, high sodium levels, too much sun exposure, or crying. Sometimes baggy eyes are inherited genetically or can develop with age.

HELPFUL HINTS:

Tips for Swollen Eyes

- Get enough sleep regularly.
- Splash cold water on your face first thing in the morning.
- Squeeze out two water-soaked tea bags and refrigerate them until they're chilled. Place them on your closed eyes for ten minutes.
- Sleep with your head raised slightly, which prevents fluids from building up under your eyes.
- Quit smoking.
- Avoid salty foods.
- Avoid drinking alcohol.
- Place cold cucumber slices on your closed eyes for five minutes.
- Drink lots of water, which helps flush out excess salt from your body.
- Don't forget to remove contact lenses before you sleep.
- Avoid rubbing your eyes.
- Vitamin K cream may help soothe dark circles under your eyes.
- Stop sleeping with feather pillows or comforters as lots of people have undiagnosed feather allergies.
- Some models swear by applying hemorrhoid cream under the eyes, but beware of skin irritation.
- To minimize upper lid puffiness with makeup, apply a dark shade of eye shadow on your upper lid, from just below the brow to the crease. Then stroke a lighter shade on the lid from the crease to your eyelashes.
- To hide under eye bags, use a yellowish shade of foundation over your regular base. Avoid covering under eye bags with pink concealer, which will make them more noticeable.

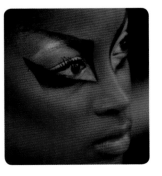

Perfectly shaped eyebrows can help you look stylish and fierce even when you're not wearing any makeup. Eyebrows frame your face, pulling attention toward your eyes, accentuating your features. Left wild or uneven, eyebrows can make your face look unbalanced. But if you've plucked your eyebrows to death, the lack of a proper frame for your face can easily make you look older and shrink the appearance of your eyes.

To sculpt your eyebrows, it's usually best to get them tweezed, trimmed, waxed, or threaded professionally first. Then it's much easier to maintain the shape yourself by plucking where the hairs grow in. You can thicken sparse eyebrows with an eyebrow pencil that matches the color of your natural hair.

Every now and then, over plucked eyebrows come back in vogue. Don't fall for the trend! The fashion never lasts and your eyebrows can take years to grow back, if they grow back at all. It's usually a good idea to stay within your natural eyebrow shape, focusing on merely plucking stray hairs from underneath the arch of your brows and above your nose, although sometimes a more radical transformation is necessary to balance out your features.

The appropriate shape of your eyebrows depends on your facial shape. Consider your decision carefully before changing the shape of your original eyebrows, but if you must, find a contour that works best for you.

Eyebrow Shapes

Straight
If you have a narrow face or eyes that are too far apart, straight eyebrows — eyebrows that travel directly across the brow line — can make your face appear wider, and pull attention away from the space that may be too broad between your eyes.

Angled

Best if you have a round or wide face, angled eyebrows arch upward from the inside and angle downward steeply from the middle of the brow toward the outside edge of the eye. The sharp slope can make your face appear slimmer, and seem to widen the space between your eyes if they're too close together.

Arched

If you have low, thick brows, try arched eyebrows, which arch upward from the inner edge, and then curve down gently on the outside. This shape will seem to broaden your eyes, and make them look brighter and more alert. Be careful not to make the arch too high on your face, or you'll end up looking permanently surprised.

Curved

Perfect if you have sharp, angular features, curved eyebrows are round in shape and follow the line of the eyelid. Curved eyebrows will soften the overall look of your face.

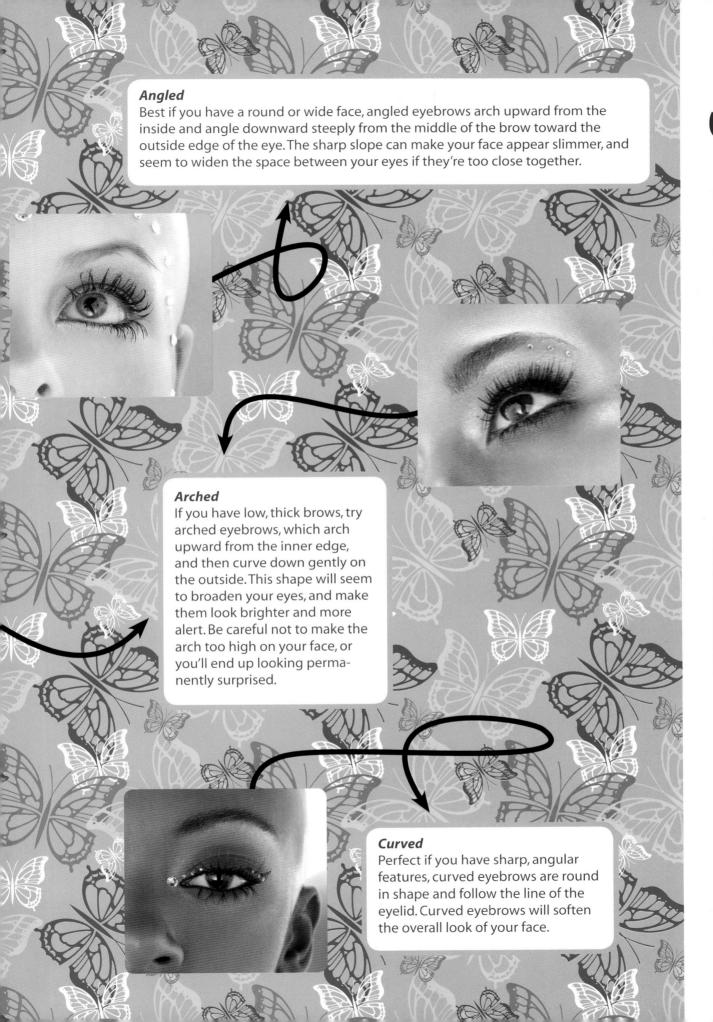

Plucking Your Eyebrows

The best time to pluck your eyebrows is right after bathing, since your pores will be more open from the heat. It's also smart to pluck before going to bed, so your eyebrows have a chance to heal overnight and your skin won't be red all day.

It's also crucial that you have excellent lighting for this task — make sure you're near a sunny window or under a bright light. Use a mirror that shows your pores clearly. A magnifying mirror is great, but don't forget to check your appearance in a regular mirror during your plucking session to get a more complete idea of the effect you're creating.

Don't over tweeze! Eyebrows can take forever to grow back. Make sure that the space between your eyebrows is approximately equal to the distance between your eyes. To find the exact inner starting point, hold a pencil parallel to the side of your nose and begin where the pencil meets your eyebrow. To find the stopping point on the eyebrow's end, hold the pencil diagonally from your nostril, connecting to the outer edge of your eye, and stop where the pencil meets your eyebrow.

Find the best pair of slant-edged tweezers you can. The tool makes a big difference by making plucking easier and faster.

Start plucking the hair between your brows, one hair at a time. Yes, the process is time-consuming, but you can do major skin damage by plucking many hairs at once. Raise your eyebrows or pull up the skin between your eyes to reveal hidden hairs. Then carefully pluck the straggly hairs above and below the eyebrow shape you desire.

To prevent over plucking, check your overall appearance in the mirror after removing each hair.

When you're finished, use a cotton ball to apply astringent, which will close your pores. It's also a good idea to rub aloe gel on the plucked area to soothe your skin.

Eyebrow Pencil

Proper use of an eyebrow pencil will accentuate your brow, add expressiveness to your eyes, and fill in sparse or faint eyebrows. When overdone, the use of an eyebrow pencil can look too severe and make you appear sinister or angry, so use a light touch. Pick a pencil shade that matches the normal color of your brows, or one that's a shade lighter than your hair color.

Applying Eyebrow Pencil

1. After sharpening your eyebrow pencil, pinch its tip and hold it for a few seconds. The heat from your fingers will shape the end and give you an accurate drawing point.

2. Start from the inside corner of your eye, but not too close to the start of the eyebrow. With gentle, feathery strokes, fill in the eyebrow, lightly adding color in an upward direction as you move along the eyebrow to the end.

3. Darken the underside of the eyebrow a little more than on top to add definition.

4. Never pencil your eyebrows with a single dark line or you'll end up with overwhelming and perhaps frightening eyebrows.

Even without speaking, your mouth communicates an enormous amount of information to onlookers. Your lips can suggest sexiness with a smirk or a puckered kiss, a sense of welcome or humor with a smile, sulkiness with a pout, disapproval with a frown, or dozens of other expressions, such as surprise, anxiousness, ecstasy, fear, anger, or admiration. Aside from your eyes, your lips say the most about the image and emotion you're trying to convey, so it's vital that your lips get the attention they deserve.

Take care of your lips! When you're not wearing lipstick, always wear lip balm to avoid flaky, split, or chapped lips. It's a good idea to wear lip balm that has SPF protection, too, because too much sunlight can seriously damage your lips.

Lip Color

Lip liner, lipstick, and lip gloss are the finishing touches to your overall makeup. To make your lips get noticed, use a solid color lipstick at least one shade deeper than your natural color. Remember that your lip liner should always be the same color as your lipstick. Do not wear black lip liner! It almost always looks cheap. Be aware that frosted lipstick rarely shows up when photographed, so avoid it on photo shoots.

Lip gloss will make your lips look plumper, so use it if you have thin lips, and avoid it if your lips are already full. Thick, full lips are greatly desirable, but you can reduce their impact by using rich, matte colors if you want to shift the focus to the rest of your face.

Don't wear a strong, vibrant lip color if you're also wearing heavy eye makeup, or you'll end up looking overdone and clownish.

Applying Lip Color

1. **Start with your lip liner. Using a fine-point lip liner in the same color as your lipstick, lightly outline your lips, keeping your hand as steady as possible so the outline is even and smooth. Start in the middle of your upper lip and line the lip outward in either direction, toward the corners of your mouth. On the lower lip, start at either corner and continue all the way across to the other corner in a fluid motion.**

2. **Fill in the outline with your lipstick, using a lip brush. Again, start in the middle of the upper lip and brush the color outward toward the edges. On the bottom, fill in the outline from one side to the other. Keep the lipstick application as thin as possible — it's much harder to remove extra lipstick and you can always add more later.**

3. **Blot your lips by pressing them lightly together on a folded tissue. This will remove excess lipstick and help seal the rest so that it stays on securely.**

4. **If needed, finish up with lip gloss for a gleaming, plumper look.**

pucker up!

Teeth

Some people, whether it's because of the color, shape, or condition of their teeth, are reluctant to smile. But models know that that can only lead to awkward moments. Learn, as famously gap-toothed super-model Lauren Hutton did, to fully appreciate the individuality your smile affords you! If you can't, or think that your teeth are too far gone, you may want to look into cosmetic dentistry procedures.

Hygiene

Keep your teeth clean! Think of brushing after every meal, flossing daily, and getting your teeth professionally cleaned regularly as investments in your smile. Your tongue often shows up in pictures, too, so keep it looking pink by brushing and scraping it, and by using germ-killing mouthwash. Speaking of mouthwash, always make sure your breath smells great when you're on a job — nobody wants to work with a beautiful woman with heinous halitosis!

Whitening

You can either whiten your own teeth or get a professional to do it for you, but your teeth must always look sparklingly white. Photographers will have to retouch your smile if your teeth are noticeably yellow. Professional chemical or ultra-violet whitening works very well, but it can be costly, and you may notice some extra sensitivity to hot and cold after the procedure.

Even if you get your teeth professionally whitened, add home whitening to your tooth-care regimen. Whitening strips really work, although not as quickly as with professional whitening.

Maintaining white teeth is another good reason not to smoke cigarettes or drink too much coffee. Some models only drink ice coffee through a straw so that the dark beverage doesn't stain their teeth!

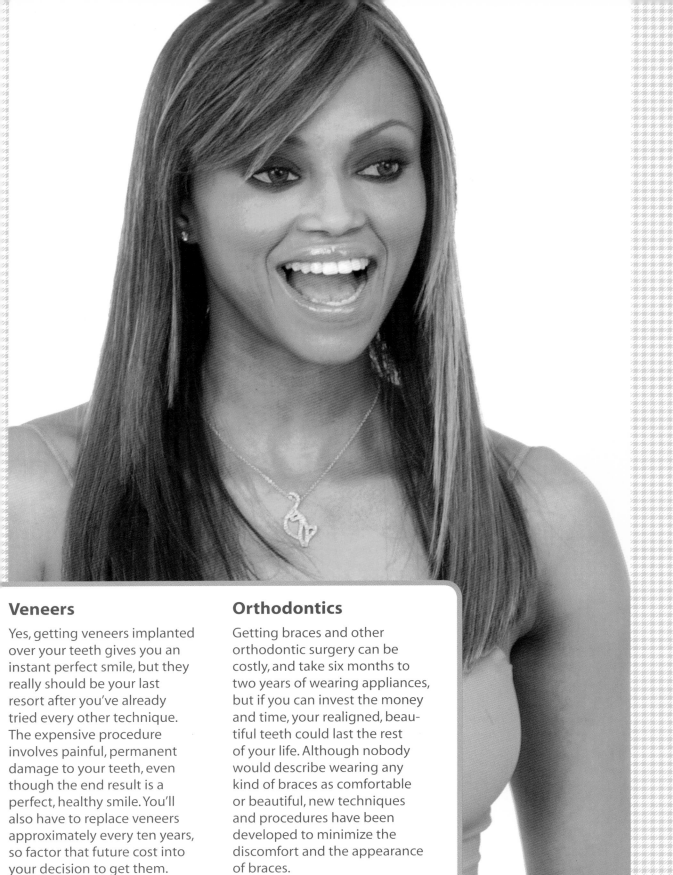

Veneers

Yes, getting veneers implanted over your teeth gives you an instant perfect smile, but they really should be your last resort after you've already tried every other technique. The expensive procedure involves painful, permanent damage to your teeth, even though the end result is a perfect, healthy smile. You'll also have to replace veneers approximately every ten years, so factor that future cost into your decision to get them.

Orthodontics

Getting braces and other orthodontic surgery can be costly, and take six months to two years of wearing appliances, but if you can invest the money and time, your realigned, beautiful teeth could last the rest of your life. Although nobody would describe wearing any kind of braces as comfortable or beautiful, new techniques and procedures have been developed to minimize the discomfort and the appearance of braces.

Smile

Almost everyone reacts in a positive way to seeing you smile honestly. It's true that a smile does show vulnerability, but a glimpse of your humanity is part of what makes it so powerful, welcoming, and beautiful.

Any good model repeatedly practices various kinds of smiles in the mirror, perfecting her look for different situations. It's important that you discover smiles that keep the fullness of your lips and minimize wrinkles around your nose and eyes. Smiling too hard can make you look grim and frightening, while showing too much teeth can make you look more hungry than friendly or sexy.

Happy Thoughts

You can practice your smiles, but you can't really get away with showing a smile devoid of enthusiasm. A fake, forced smile can make you look phony, nervous, or even creepy, so don't try to put on a smile without first putting yourself in a happy state of mind. To make your smile look genuine, it has to be genuine. For a natural, believable smile, recall your happiest memory, think of a joke, or remember a funny scene from a movie. Don't laugh out loud, though — that's a completely different expression on your face, and often shows too much teeth.

In some situations, your brightest smile may be overkill. If you smile too wide, you may look overly enthusiastic to the point where it seems fake again. Rather than always reaching for your biggest smile with your happiest memory, instead recall a moment when you felt calm and content, which can produce a light, seductive smile perfect for a flirty look. Or try remembering a time when someone gave you an unexpected gift, so you can flash a surprised, giggly grin.

Keep practicing your smiles in the mirror, pulling up your funniest memories until you can bust out an honest, earnest smile on demand.

Face Shaping

For photographs, some big smiles can distort the shape of your face, so practice adjusting your facial muscles in the mirror so that you can maintain your beautiful look even when you are glowing with a smile. Start by smiling naturally, but gently tense the muscles below your lips to widen your smile and tighten your chin. You should be able to feel your smile affecting your muscles all the way up to your cheekbones, but to avoid squinting your eyes, make sure to widen your eyelids while you're smiling.

It also helps to stretch your neck and jut out your chin a little, which will help prevent you from photographing as though you have a double chin while you're smiling.

Smiling with Your Eyes

What people really respond to when you smile is the cheerful, warm twinkle in your eyes, not just the shape of your mouth. If your smile doesn't show in your eyes, it won't read as genuine, which is another reason why you must honestly feel happy when projecting a smile. To really boost the wattage of your smile, imagine your eyes glowing with a joyful inner light.

Practice smiling with your eyes in the mirror. Put on your best, most natural smile, thinking of your most elated memory, but concentrate on the effect your eyes are creating. It might be helpful to cover your mouth with a piece of paper so you can really focus on projecting humor and warmth with your eyes. Once you get the hang of smiling with your eyes, the expression will cheerfully affect your body language, loosen your facial muscles, and pull your mouth into a sincere, gorgeous smile.

Beginner's List of Smiles

1. *Smiling with Your Eyes*
 Crucial — without it, all smiles feel fake and forced.

2. *Angry Smile*
 A fierce look for your smiling repertoire, as though you're pretending to like an enemy, but not appropriate for all situations.

3. *Flirting Smile*
 For a softer, come-hither look, smile gently, and turn your shoulders and tilt down your head.

4. *Surprised Smile*
 Useful for reactions to products, with wide eyes and a more open mouth. Act like someone just gave you a diamond ring and you have no idea why, but you're thrilled anyway.

5. *Commercial Smile*
 A matter-of-fact, calmly happy smile, over the shoulder, will help you look relatable to a larger audience.

6. *High-Fashion Smile*
 See any issue of *Vogue* magazine for this shocked, giddy expression used by almost all high-fashion models. The head is turned, with a hand up on the side of the face, as though you just saw something surprisingly hilarious. The eyes are closed, and the mouth is wide open in a smile.

Hair

Your hairstyle is one of the essential factors in your overall look, but there is so much variation in different cuts, lengths, colors, and textures that specific discussion of which style would work best for you is an exceedingly individual choice and beyond the scope of this book. For modeling, a simple, chic, elegant style that perfectly frames the particular shape of your face is best.

Yes, a high-impact hairstyle will win you some attention, but consult with your personal hairstylist, and cautiously consider a new hairstyle before deciding to wear a radical cut or shocking color. Photographers and fashion editors often choose models who have a flexible hairstyle that allows for a range of looks, which can be adjusted depending on the needs of the photo shoot.

Always keep your hair clean and neatly styled, and avoid hair accessories and unnecessary styling products. It's often a good idea to keep your hair away from your face, unless you need bangs to soften the effect of a high forehead or awkward face shape. Make sure your hair is the right color for your skin tone — neither too dark or too light. If you have a weave, get a great one that matches your hair color exactly, and maintain it carefully.

For couture-fashion photo shoots and formal events, your hair should often be slicked back, upswept, or styled in a classy chignon.

Face Shapes

Finding Your Face Shape

Pull your hair back away from your face and secure it with a headband or ponytail. Use the corner of a bar of soap to outline the shape of your face on the surface of a mirror, and then step back. Decide which shape — round, oval, oblong, triangle, heart, or square — is closest to the shape of the outline, and there's your face shape!

Types of Face Shapes

Round

If you have a rounder face, with soft cheekbones and a wider chin, find a hairstyle that adds length to your face and minimizes volume around it. Don't wear blunt cuts, curly styles, or short hair. Bangs are fine, if you keep them long or swept to the side. The best style would be layered at the top and tapered down, falling just below the chin.

Oval

An oval face shape is the most versatile, and looks great with almost any kind of hairstyle. The only cuts to avoid are short layers that add height to the top of your head, which may make your face look too long, or short, blunt cuts if your hair is curly or thick, which will give you too much volume.

Oblong

For this longer face-shape, you will want to lessen the effect of your face's length and add the illusion of width. Bangs that almost reach your eyebrows and chin-length or shoulder-length bobs will usually be flattering. For a little more visual interest, keep the back slightly shorter. Curly,

wavy hair often works well with oblong faces, too. Avoid keeping your hair too long as it shouldn't reach past your collarbone. Extremely short haircuts should be shunned, as well.

Triangle

Balance your narrower forehead and wider jawline with short, voluminous hair. Lots of curls on top in a shorter length will help minimize the appearance of your strong chin. Wedges, shag cuts, heavily layered hair, and off-center parts will also help balance your face. Don't wear long, bulky styles that add weight to the base. If your style is a little longer, try tucking your hair behind your ears.

Heart

Don't wear short, straight bangs or choppy layers. Keep your top layers soft and long with short hair, and grow long layers that brush your cheekbones with longer hair. Draw attention to your cheekbones and eyes instead of your pointy chin with a bold part, side-swept bangs, or a length that falls past your jawline.

Square

Minimize the look of your broad, angular jaw by adding volume at the top of your head and wearing your hair thinner as it tapers down the sides. Curls, choppy ends, or other methods of adding texture to your hair will pull the attention away from your jawline. Chin-length bobs and square bangs will only accentuate the blockiness of your face. For a cool look, try a spiky, short cut, or a long style that starts layering at the jawline and continues down sleekly.

Body Hair

Yes, you're secretly a hairy beast. While there is no medical or hygienic reason to get rid of your body hair, the current standards of beauty absolutely require you to remove all hair from your armpits, legs, and face for a smooth, youthful look. It's a regular chore that every model must handle. If you're going to be modeling a bathing suit or lingerie, you will definitely need to groom your bikini line.

Try to schedule all hair removal a few days before actually appearing in public so that all traces of irritation have disappeared, but before stubble reappears.

You can shave, bleach, tweeze, and remove hair with depilatory creams by yourself, but waxing is usually best left to a professional. Permanent and semipermanent methods of hair removal (electrolysis and laser) must also be performed by qualified technicians.

Shaving

Since it's inexpensive and relatively easy, shaving is the most popular method for removing unwanted body hair. It's also the shortest lasting — stubble starts growing back after only a few days. And unless you're very gentle and careful, you can often get ingrown hairs. It's a good idea to shave in the shower, after the warm water has opened your pores and softened your skin. Using a gentle shaving gel, shave slowly in short strokes in the direction that your hair grows. It helps to pull certain areas of skin tight so you get a clean shave. Switch to a new razor often, which will help you avoid ingrown hairs and small cuts.

Tweezing

Only tweeze your eyebrows, or a random stray hair or two elsewhere on your body. Do not try to tweeze large areas of hair, as it's incredibly painful and leaves your skin red and damaged.

Bleaching

Bleaching is a popular method of making unwanted hair less noticeable by dying your hair a light blond. It does not remove hair. Facial hair, including your upper-lip hair and arm hair, can be bleached with kits available at all drugstores. Or for better results, get it done professionally at a salon.

Waxing

Waxing is one of the most effective methods of hair removal, and it can last from three to five weeks, as well as make regrowth sparser and softer. If you're waxing your own hair, don't forget to make sure to pull the strip of cloth against the direction of hair growth, in a direction parallel to the skin, which will make it somewhat less painful. Rubbing a small amount of olive oil on your skin afterward can remove excess wax and soothe your skin, too. For best results, though, get your waxing done professionally, or have a professional

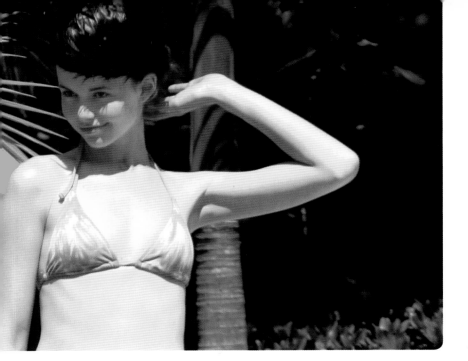

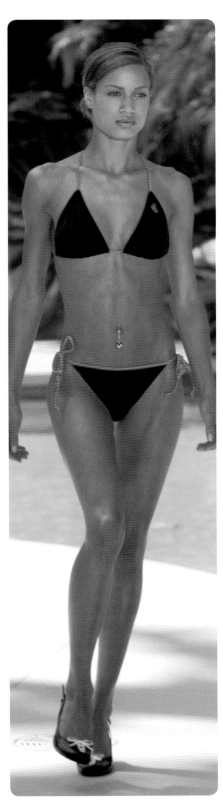

wax difficult areas like your bikini line. Yes, even done by an expert, waxing stings. Pop some aspirin, ibuprofen, or acetaminophen a half-hour before the procedure to take the edge off the pain.

Depilatories

Depilatory creams temporarily remove hair by chemically dissolving it down to the root. Certain creams are only meant for particular parts of the body, so make sure you're using the correct formula listed on the package. Always perform a sensitivity test on a hidden area of your body before using the cream everywhere, or you might end up with a long-lasting rash. See if you can find a depilatory cream with a smell you don't hate.

Laser

A relatively new technique that uses an intense beam of light to deaden hair follicles, laser hair removal has converted many people with great results. Depending on the type of hair you have, laser hair removal can last as long as a few months. Repeat visits may be necessary, especially for blondes or redheads, and some discoloration has been reported in women with darker skin. It's also considerably more expensive than waxing, but the bonus is that you might only need to have it performed two or three times a year.

Electrolysis

Electrolysis is a procedure in which a tiny electrode is poked into each of your individual hair follicles, one follicle at a time, and is then pulsed with a brief electrical current, killing the hair at the root. Sometimes after one procedure, but more commonly after a few visits to a licensed practitioner, your hair will have stopped growing back completely. It's the only officially permanent hair removal procedure, but it's expensive, time-consuming, painful over a large area, and occasionally causes scarring. But it works!

Nails

Get professional, classy manicures and pedicures. Your nails should be clean, even, and unobtrusive, with a short length in a neutral color or French manicure. Bright or garish colors call too much attention to your hands, and may clash with your overall look. Wearing nail polish strengthens your nails, so at least use a clear polish to maintain nail health.

Avoid filing your nails. Buffing is much gentler and actually stimulates nail growth.

If you're doing your nails yourself, start with very clean nails that are free from old polish. First apply a base coat and then a main coat in three strokes, one down either side and a final stroke down the middle. Dry your nails for a few minutes before adding a top coat to make the nails stronger and keep your polish from chipping easily.

Stay conscious of caring for your nails. Never open soda cans with them, don't bite them, or pick at the polish. Getting your nails wet repeatedly for long periods of time also weakens them, so wear rubber gloves when cleaning your home. Too much nail polish remover can make nails brittle and more prone to splitting, so try to remove your nail polish only once a week at most.

Keep your nails well-moisturized, which will protect them from splitting, help them grow longer and more evenly, and prevent hangnails and jagged cuticles. Don't cut cuticles as they just grow back harder and more obvious. Soaking your nails in olive oil or milk will moisturize them nicely, but a regular hand moisturizer works, too. Remember that nails lose moisture faster than the rest of your hand.

If your nails are particularly chewed-up or uneven, you can apply fake nails. But don't choose ones that are too long or paint them crazy colors. You should always aim for an elegant and discreet look for your fingernails unless you're aiming for a wild appearance.

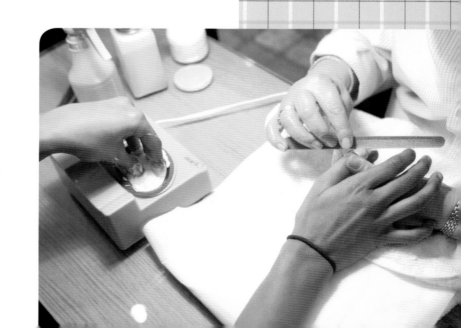

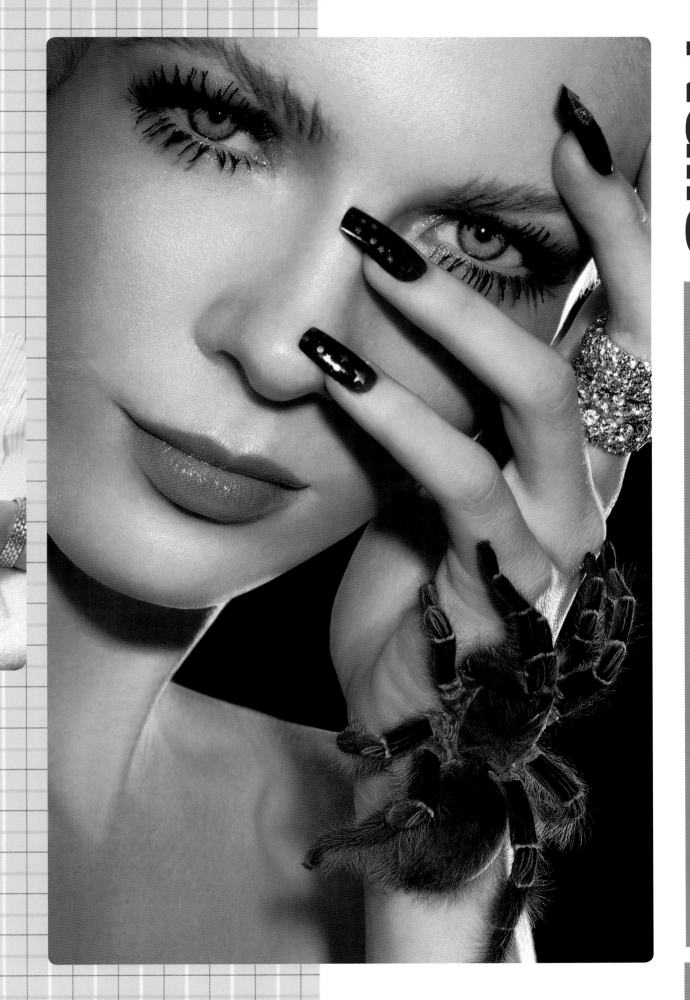

The term "beauty sleep" is not a myth. Sleeping well is crucial for your health and looks, enabling you to re-charge your batteries, work through issues in your dreams, and allow your body to relax. When you sleep, your body is doing more than simply resting — it's healing and repairing itself. You should get eight hours of sleep every night whenever you possibly can.

Also, your muscles regenerate themselves during the final hours of sleep, so the more regularly you remain asleep for a full night of rest, the more your metabolism has a chance to increase along with your muscle mass. Sleeping well also makes your body relax and produce less of the hormone cortisone, which is known to contribute to the retention of belly fat.

If you sleep well every night, you'll avoid puffy, bloodshot eyes, dark under eye circles, aching limbs, and a pale washed-out complexion, as well as maintain a high level of energy, upbeat attitude, and alertness for whatever your busy day may bring.

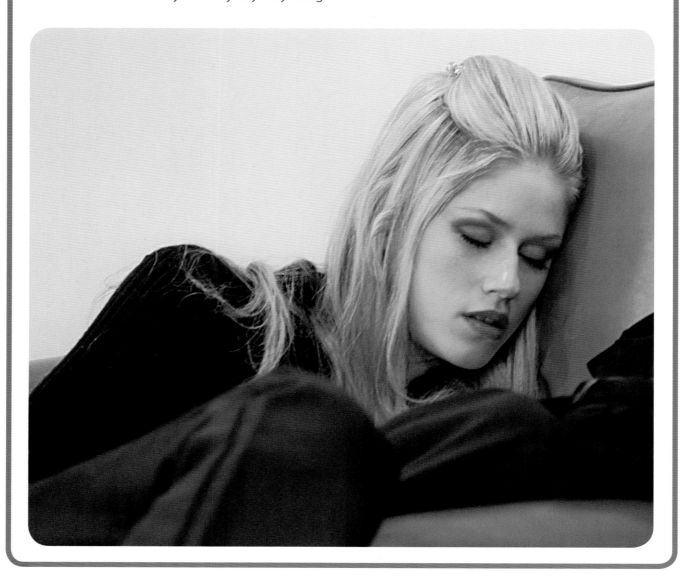

HELPFUL HINTS:

Tips for Sleeping Soundly

- Exercise every day, but not in the few hours before bedtime.

- Don't eat a large meal right before bed as a busy digestive system can keep you awake. Avoid spicy foods, too, although a light, healthy snack can settle hunger pangs.

- Make sure your bedroom is set at a comfortable temperature, usually around 68 degrees.

- Don't read, watch television, or work in bed.

- Don't smoke cigarettes or drink anything with caffeine at least four hours before you need to sleep. Avoid all stimulants before bedtime.

- Light and dark affects your internal body clock, so make sure your bedroom is dark when you're sleeping, and reset your clock in the morning by opening your window shades or turning on the lights immediately.

- If you are having trouble sleeping at night, skip those naps during the day. If you must nap, try to nap only for 30 minutes early in the afternoon.

- Don't drink alcohol before bed. While it can help you fall asleep faster, you may wake up during the night. Alcohol also negatively affects the quality of your sleep.

- Try not to read upsetting books or articles before bed, and avoid worrisome TV shows or movies, so that you aren't feeling anxious when you try to sleep.

- Establish a relaxing routine before bedtime like listening to soft music or soaking in a warm bath.

- If your bedroom is affected by outside noise, consider using earplugs, keeping a white-noise machine or fan running at night, installing double-pane windows or heavy drapes, placing a rug on the floor, or listening to relaxing music as you sleep.

- Consider buying a better mattress and more comfortable pillows.

- Set a consistent schedule for your sleep and waking times.

If you think that you'd like to put your beauty to work for you, you might want, as the contestants on **America's Next Top Model** do, to try your luck in the fashion industry. Fashion uses beautiful models to display the next season's clothes to buyers, magazine editors, celebrities, and the public. As a model you must live and breathe the whole world of fashion.

Fashion design is the art of creating clothing and accessories within a framework of current social and cultural influences, aiming to represent the next fashion season as a modern point in time. It usually strives to be based in historical knowledge of fashion trends, while also moving the art form a step forward. Fashion is unique among art forms in that each piece of art has a built-in expiration date as it is only meant to last a season or two, either autumn/winter or spring/summer.

A fickle art form, fashion is always changing, but it has the power to transform the look of large groups of people and make strong statements about the issues of the day. For people inside and outside the industry, fashion is ultimately a method of creatively expressing yourself and accentuating your beauty.

Types of Clothing Design

Haute Couture
French for high fashion, haute couture refers to any garment made to order for an individual client. Officially, only companies that meet the standards of the French Chambre Syndicale de la Couture can call their garments haute couture, but some fashion companies use the term loosely for any unique item of clothing created for a specific customer. The most artistic of the types of fashion, haute couture involves garments made from pricey fabrics and sewn with great

attention to detail. The fit, beauty, and artistic significance are more important than the cost of the clothing or how long it takes to make it.

Ready-to-Wear
Ready-to-wear (from the French prêt-à-porter) clothes are sewn with care from good fabrics, with an eye on artistic style, in small quantities to guarantee expensive exclusivity. A designer's ready-to-wear collection is presented to the industry at Fashion Week in various cities around the world, and is available in high-end department stores and boutiques.

Mass Market
The season after a popular ready-to-wear line is shown, there is sometimes a mass-market line of reproductions released to the general public in larger mass-produced, inexpensive, and easier-to-manufacture versions. Some designers have a separate division that produces these mass-market adaptations of their ready-to-wear line. There are many companies that follow the popular trends and produce mass-market clothing directly, as well.

How Fashion Works

A few months before a designer's line of clothes is scheduled to appear in stores for a season, the fashion industry, including the press (magazine and television editors, reporters, photographers, and style gurus), celebrities and socialites, buyers for boutiques

and department stores, and other designers attend fashion shows presenting the new collections of clothes worn on the runways by models. The media then releases stories about the fashions that they believe will most interest their audience, and the buyers from major stores soon follow with their orders for the lines they think will sell. The celebrities and socialites are usually the first to wear the clothes, which can provide more exposure for the clothing line and can influence the public.

There's another way fashion works — up from the streets. Certain new trends develop spontaneously in urban communities as signs and symbols of the neighborhood. These community fashions are usually quickly adopted by designers, who keep a sharp lookout for emerging street fashion.

But no matter the influence of designers or celebrities, the general public makes the ultimate decision about whether or not a new fashion trend is going to fly by choosing to wear it.

Despite all the outrageous possibilities of fashion, your beauty, along with simple, chic, flattering clothes are all you need to present yourself correctly. When you go on interviews or "go-sees," they have to be able to imagine you representing their company to the public. If what you're wearing is too extreme or specific, they may not be able to see how your style works with what they need. Keep your look as pared-down as possible, while still displaying your own style with a touch of current trends.

In your personal life, always remember that people often look to those who look like models even on the street for inspiration. So read fashion magazines and stay hip to the most updated looks, even if you only use trends as an accent to a classic style.

Speaking of your style, there are a few guidelines to follow that will always help you maintain a classic look. Start with simple, elegant lines in your clothing, and choose garments that fit you properly and flatter your figure with a playful silhouette. Don't hide in baggy outfits. Properly fitted clothes will also help you stay comfortable, which is crucial to your confidence.

To stay sexy, find tops with necklines that suit your body type, and clothes that move well when you walk. It's almost always a good idea to keep your overall look in a single color with a chic accessory to provide a focal point and express your personal style. Make sure you update your wardrobe frequently, which means getting rid of items past their expiration date, and adding a few new pieces for a trendy touch.

Be brave and break the rules of fashion occasionally in order to more fully realize your own vision of yourself. All current trends began with someone trying a new style and making it work with their own playful self-confidence. But save your experimentation for your personal life, not when you're trying to land a job as a model.

Don't be afraid of fashion!
—James St. James

Accessories

Don't over accessorize! Choose a single, hot accessory that enhances your outfit and provides a resting place for the eye, and draws attention to the best features of your body without overwhelming your outfit.

Find signature accessories that express your personal style and become representative of your look, such as sunglasses, bags, earrings, an heirloom necklace, or a certain shade of lipstick. It's best to choose accessories that work with a wide variety of clothing styles so you can carry your signature look across a range of attire. Surprise everyone by using your personally representative accessories in unexpected, innovative ways, like using your scarf as a belt, or wearing your jewelry in your hair. Make a statement!

Keep up with the trends in fashion magazines to make sure that your accessories are on the cutting edge and that they remain in style. Follow the careers of the top accessory designers and design houses, too, such as **Max Azria, Coach, Kenneth Cole, Cole Haan, Hermès, Nanette Lepore, Emilio Pucci, Kate Spade, Bottega Veneta, Cynthia Vincent, and Louis Vuitton,** as well as the hot accessory lines from almost all of the influential fashion designers and design houses.

Have fun with your accessories, and use them to express your personality, but don't make too many bold statements at once or they'll clash confusingly. Keep it simple.

Designers are the artists and craftspeople of the fashion industry, pushing the boundaries and maintaining the milieu of clothing design. You must know who they are if you want to be fierce. Some designers are freelancers, working directly for clients from their individual boutiques or selling directly to manufacturers, while some are employed by larger houses with long-established reputations. Design houses with the biggest names often employ dozens of designers who work under a head designer who provides direction for each season's style.

Familiarize yourself intimately with the designers and fashion houses on the list below and on the next page. Keep an eye out for their names in magazines and follow their careers in the news, especially when the designers move from one fashion house to another. All of these designers have had influences on modern fashion design, so research their contributions to the art, and never let your ignorance of their impact be an issue.

Designers

Gaby Aghion
Giorgio Armani
Pierre Cardin
Coco Chanel
Dolce & Gabbana
Patricia Field
Tom Ford
John Galliano
Valentino Garavani
Jean Paul Gaultier
Hubert de Givenchy
Gucci
Carolina Herrera
Tommy Hilfiger
Marc Jacobs
Betsey Johnson
Donna Karan
Calvin Klein
Michael Kors
Christian Lacroix
Karl Lagerfeld

Designers

Ralph Lauren
Bob Mackie
Catherine Malandrino
Stella McCartney
Alexander McQueen
Badgley Mischka
Isaac Mizrahi
Thierry Mugler
Zac Posen
Miuccia Prada
Oscar de la Renta
Cynthia Rowley
Paul Smith
Anna Sui
Emmanuel Ungaro
Carmen Marc Valvo
Gianni and
Donatella Versace
Diane von Furstenberg
Vera Wang
Vivienne Westwood

To fully understand where modern fashion design is coming from, and to figure out where it's heading in the future, you must be familiar with its past. Fashion design repeatedly references its history, updating old styles and reintroducing forgotten trends with a contemporary twist. There is a cycle of fashion design over time, and the more you know about the history, the better you'll understand current developments in fashion.

Charles Frederick Worth (1826 – 1895)

The first person to sew his label into his garments, Charles Frederick Worth is widely considered to be the father of modern fashion design. He was one of the first designers to create replications of his haute couture designs for wider sale after showing them on the runway, helping to initiate the ready-to-wear business.

Paul Poiret (1879 – 1944)

Poiret brought the enormous influence of modern art into fashion design, working in aesthetics based on the Art Deco, Surrealist, and Deconstructionist movements. He was also one of the first designers to use draping as a design method, rather than tailoring or pattern-making, and one of the pioneers of using expressive, unexpected color in his designs.

Coco Chanel (1883 – 1971)

Breaking free of the corset and uncomfortable clothing, Chanel introduced more freely fitted clothes with a style of elegant, expensive simplicity, and she championed the authority of her famous power suits, as well as the little black dress. She was one of the first worldwide fashion celebrities, and used the power of her brand to branch out into designing accessories, such as jewelry, bags, and perfume.

Historical Designers

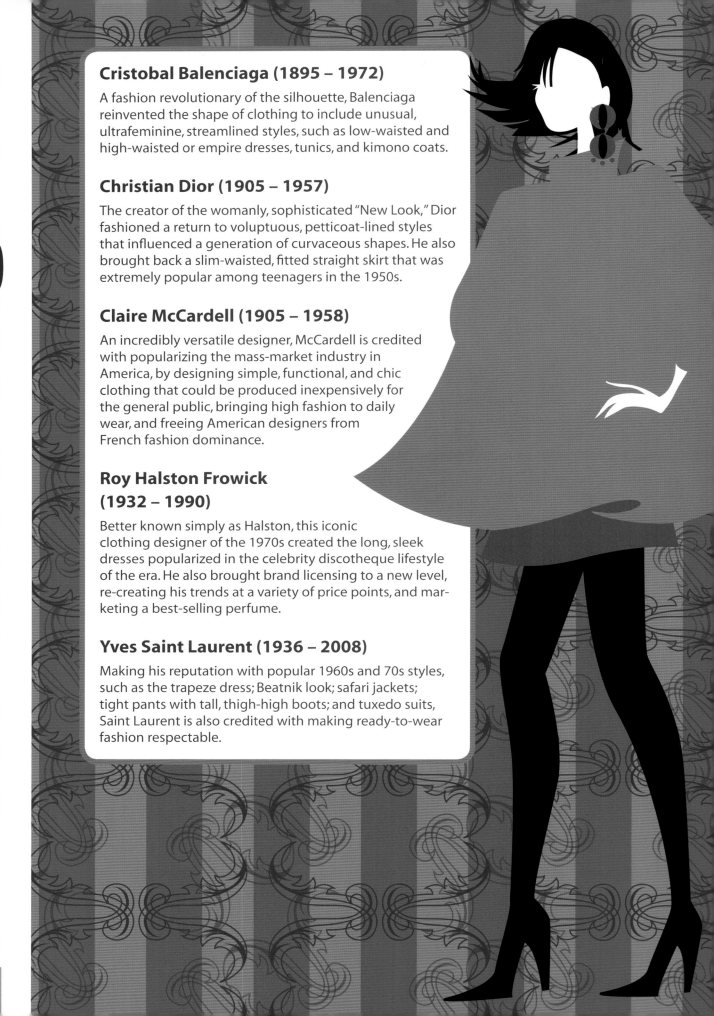

Historical Designers

Cristobal Balenciaga (1895 – 1972)

A fashion revolutionary of the silhouette, Balenciaga reinvented the shape of clothing to include unusual, ultrafeminine, streamlined styles, such as low-waisted and high-waisted or empire dresses, tunics, and kimono coats.

Christian Dior (1905 – 1957)

The creator of the womanly, sophisticated "New Look," Dior fashioned a return to voluptuous, petticoat-lined styles that influenced a generation of curvaceous shapes. He also brought back a slim-waisted, fitted straight skirt that was extremely popular among teenagers in the 1950s.

Claire McCardell (1905 – 1958)

An incredibly versatile designer, McCardell is credited with popularizing the mass-market industry in America, by designing simple, functional, and chic clothing that could be produced inexpensively for the general public, bringing high fashion to daily wear, and freeing American designers from French fashion dominance.

Roy Halston Frowick (1932 – 1990)

Better known simply as Halston, this iconic clothing designer of the 1970s created the long, sleek dresses popularized in the celebrity discotheque lifestyle of the era. He also brought brand licensing to a new level, re-creating his trends at a variety of price points, and marketing a best-selling perfume.

Yves Saint Laurent (1936 – 2008)

Making his reputation with popular 1960s and 70s styles, such as the trapeze dress; Beatnik look; safari jackets; tight pants with tall, thigh-high boots; and tuxedo suits, Saint Laurent is also credited with making ready-to-wear fashion respectable.

Kristian Aadnevik
Victoria Bartlett
Thom Browne
Benjamin Cho
Melissa Coker
Louise Goldin
Rogan Gregory
Sari Gueron
Phillip Lim
Hannah Marshall
Joanne Reyes
Angel Sanchez
Proenza Schouler
Christian Siriano
Karen Walker
Matthew Williamson

What will the future of fashion design be? Perhaps one of the newer designers on the list on the left will create the breakthrough design that will influence the next generation. By no means should this list be considered complete, since every Fashion Week a new designer causes a stir in the industry. It's up to you to keep up with the newest trends, and that means following the careers of the up-and-coming designers on the scene, as well as listening to the buzz in the industry about the latest fashion stars.

Emerging Designers

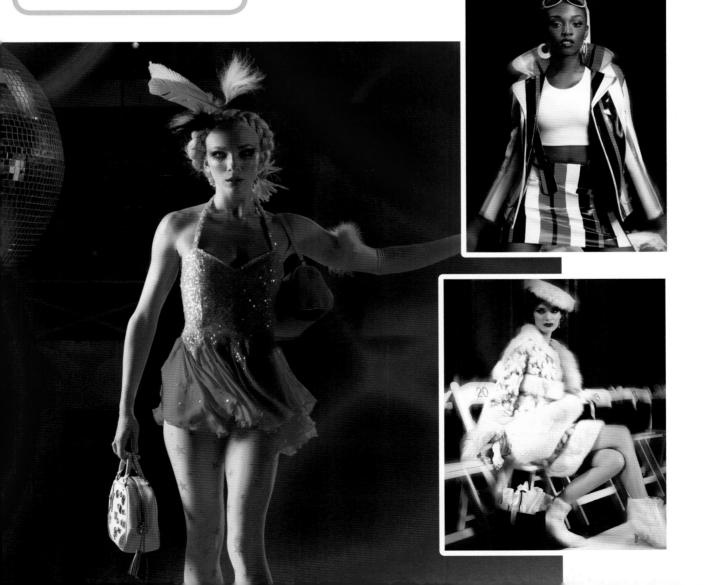

One of the key players in the fashion industry is the fashion photographer. Every model nurtures personal relationships with as many photographers as possible, since they're the ones who make beautiful, striking, and unforgettable images of them and provide the gateway to their audience.

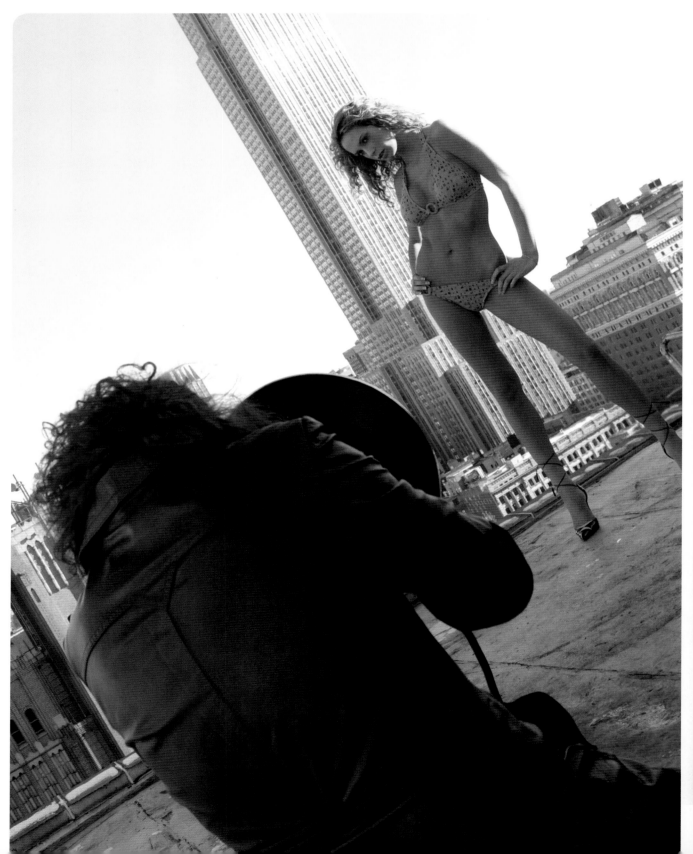

Familiarize yourself with the big-name photographers in the industry, and be able to cite examples of their impressive work. Always check photography credits in fashion magazines, and strive to model for the best photographers. Shooting with one great, well-regarded photographer can make your career.

It's also important to be picky about the lesser-known photographers you work with. While you should feel free to model for talented newcomers, beware of amateurs without credentials who don't have your best interests at heart. Analyze their work to make sure they're on the level and make sure they act professionally at all times.

On a photo shoot, relax and enjoy yourself while listening carefully to the photographer's direction, and put all your efforts into connecting with the photographer to inspire gorgeous pictures. A fashion shoot is a collaborative effort between the photographer, stylists, director (often a fashion editor), and you, the model, so it's crucial that you add your own creativity to the photographic setting, as well as your attitude, style, and poses. Deliver a wide range of varied looks within the appropriate guidelines for the particular approach of that photo shoot, without needing endless coaching.

Some names of famous fashion photographers past and present that you should know include **Richard Avedon, Nigel Barker, Patrick Demarchelier, David LaChapelle, Donald McPherson, Steven Meisel, Helmut Newton, Herb Ritts, Mark Seliger, Juergen Teller, Mario Testino, Albert Watson, and Bruce Weber.**

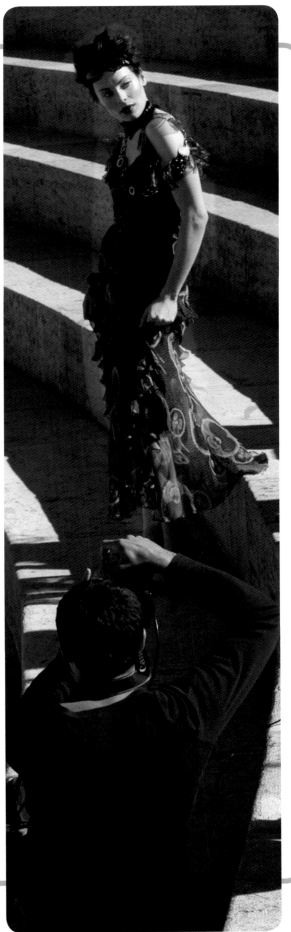

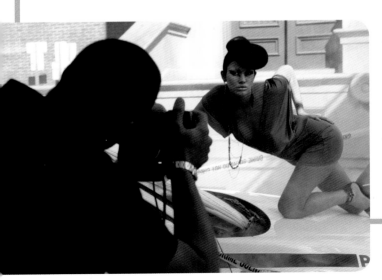

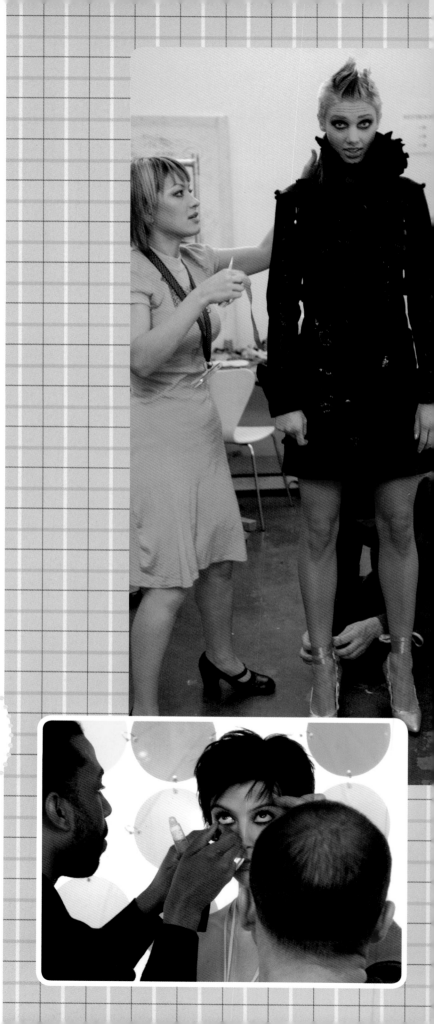

stylists

Hair, makeup, and wardrobe stylists will often be on set with you for photo shoots and behind the scenes of runway shows, and it's vital that you remember that they are artists in their own right. Models are the human canvas they use to display their creativity. Befriend as many stylists as you can as they're the ones who work their magic to make you appear beautiful and professional in a multitude of situations.

While you're allowed to express your opinions about your styling on a shoot or during a runway show, remember that stylists often are following very specific directions from directors, editors, and designers, so don't be demanding or argumentative. You shouldn't allow yourself to be hurt in any way, but keep an extremely open mind about the artistic possibilities of the way they may style your look even if it doesn't match your own ideas or aesthetic. Your job is really to flaunt their creativity and bring it beautifully to life, not to second-guess their efforts.

> *The makeup artist is your last front to the world, so you never want to piss them off, because they'll mess you up.*
>
> — Jay Manuel

QUESTIONS AND ANSWERS:

Interview with Christian Marc, hair stylist on *America's Next Top Model*

What led you to a career as a professional stylist, and what is the particular skill or talent you possess that makes you such a celebrated stylist?

I fell in love with creating shapes, and I can be very eclectic and creative, working in the most classic styles to the edgiest.

What's your favorite thing about working with models?

They are like canvases.

. . . And your least favorite?

Bitchiness.

What is your most indispensable tool for styling hair?

My medium-barrel curling iron. I can create any kind of space with it.

What tips would you offer a model about how to style her hair to achieve her own personal look?

Be simple — don't overdo it.

What tips would you suggest to a model who has to appear on a shoot where there won't be a stylist available?

Wear a simple ponytail or bun.

What would you say are the main differences between hair styles for high fashion and styles for commercial modeling?

Commercial is very mainstream, so the hair is styled very naturally. High fashion is the opposite — you can explore and create interesting effects and play around with the story line.

How should a model physically prepare her hair before she appears in your chair?

Never show up on set with wet hair!

What suggestions would you give a model about how to treat her stylists?

With respect!

What's your biggest annoyance about how models behave in your chair?

I can't stand when they tell me what to do.

What is your favorite tip for managing hairstyles?

Hairspray. And don't touch!

What is your favorite historical hairstyle look?

I have so many favorites, but I go for the late 60s, early 70s.

Do you have a tip for a technique, look, or color that could be a future trend?

Over-processed hair — one day, I hope. That would make the hair way easier to manipulate and way more fun to style.

Introduction

In order to look and act like a model, you have to remember what every model knows: modeling is show business. You need to use your face, body, emotions, and behavior to promote a product, yourself, to the general public. It takes talent, or what is known as the "x-factor," which is made up of the rare, innate ability to intensely convey emotions, attitude, and beautiful style. But it takes skill and discipline as well in order to develop your talent and perfect the techniques of this demanding craft. Both talent and technique are necessary. Without talent, although you may learn to pose, you won't truly shine, and likewise, without skill, you won't be able to develop your raw talent to a successful professional level.

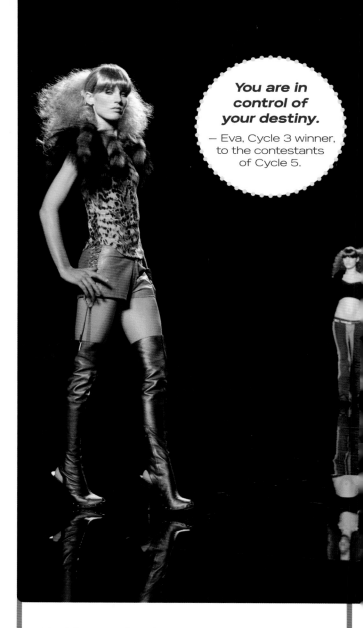

Modeling can be glamorous, thrilling, and very profitable, with amazing opportunities for traveling around the world with the jet set; it's no small wonder that it's also an incredibly competitive business. The fashion world is rife with rejection, insecurity, depression, frustration, and pressure. You must learn to counter these negatives with hard work, stamina, and persistence.

Most of all, if you have good reason to believe you have talent for modeling, you must hold fast to that belief and remain unshakable in your determination. Absorb and practice the skills of modeling until you are one of the world's expert professionals. Never forget your reasons for wanting to be a model and never lose your drive and passion for allowing your beauty to glow.

Modern fashion modeling began in Paris in the early 1850s, when the father of fashion design, Charles Frederick Worth, had his wife, Maria Vernet Worth, display his designs by wearing them at private runway shows. Charles Frederick Worth was one of the first designers to create a ready-to-wear fashion line, and since then, the rise of modeling has mirrored the popularization and marketing of ready-to-wear clothing.

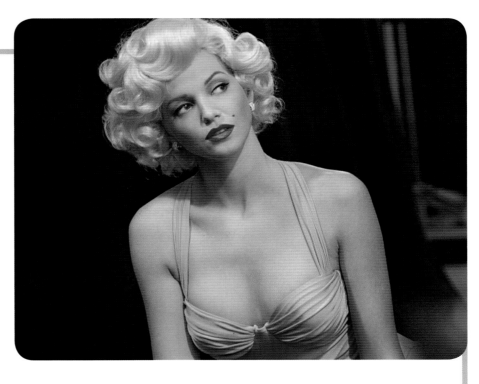

However, until the mid-1920s, modeling was still considered a low-class profession, with almost no respect given to the models themselves. Around 1924, another French designer named Jean Patou began selecting his models carefully to represent an ideal look for his clientele, allowing his wealthy audience to identify with the designs. The profession of modeling began to receive more acceptance, and the first modeling agencies began opening in Paris, London, and New York.

Models first started becoming famous and wildly successful with Lisa Fonssagrives, a Swedish model popular in the 1930s through the 1950s. She is often credited retroactively with being the first supermodel, in that her recognizable image and fame, rather than merely her beauty, were employed to sell products. Fonssagrives was followed by the American supermodel Dorian Leigh, who was renown in the 1940s through the 1960s for her particularly photogenic elegance and grace.

The term "supermodel" is said to have been in use since the mid-1940s by certain modeling agencies, and it rose to attention again in 1968 when *Glamour* magazine used it to describe a group of top models, including Twiggy, Cheryl Tiegs, and Wilhelmina. The term didn't reach its full cultural peak until the 1980s.

Janice Dickinson's claim to have coined the term "supermodel" about herself in the 1960s is hotly disputed, but there's no doubt that Dickinson was one of the most respected and successful supermodels of the modern era — or that she was the highest-paid model of her day.

Other notable supermodels you must know include **Tyra Banks, Christie Brinkley, Gisele Bündchen, Naomi Campbell, Cindy Crawford, Linda Evangelista, Iman, Heidi Klum, Elle Macpherson, Kate Moss, Beverly Peele, Claudia Schiffer, and Christy Turlington.**

Recently, the influence of the supermodel has waned somewhat, as designers often use celebrities from other professions to pose or walk in their fashions, or they work to pull the attention away from the model and back to their designs.

History of Modeling

While fashion modeling is the most prestigious category in the profession, there is a multitude of other kinds of work available to models. If you don't fit the rigid fashion criteria for runway and magazine modeling, you can still achieve great success in the commercial, fitness, glamour, parts, fit, or promotional categories of modeling.

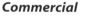

Fashion

Modeling haute couture and ready-to-wear clothing in high-end fashion magazines and on the runways are the premier gigs for any model. Because of that, fashion modeling is insanely competitive and has the strictest physical standards. While the financial rewards are ultimately the most lucrative in the industry, most fashion models start with very low pay until they manage to build up an impressive portfolio.

Commercial

The backbone and the bulk of the modeling industry, commercial modeling includes TV advertising, print advertising, catalogs, billboards, book covers, product packaging, and many other types of promotional material. The requirements for models in commercial work vary, as clients seek attractive models who embody an appealing, specific look appropriate to sell or publicize their particular products or services.

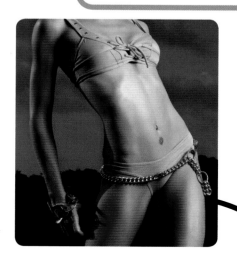

Fitness

To be a fitness model, you need to have great muscle definition. This means that you will need to maintain peak physical shape by working out. Fitness models appear in fitness magazines or model fitness-oriented goods and services, such as sportswear, swimwear, specific gyms, athletic equipment, and health foods, drinks, and supplements.

Glamour

Glamour modeling is the general term for posing in lingerie or bikinis, semi nude or nude, or for artistic, erotic photography — not pornography. You need to be at least 18 years old to model for glamour shots, and be extremely comfortable with the sexiness of your body.

Parts

Many advertisements show only the hands, feet, legs, mouth, hair, or other specific body parts of the model according to what the product advertises. Modeling scouts for these jobs look for models who have the exceptionally beautiful part that will be featured in the ad, but who aren't necessarily gorgeous overall. Most parts models specialize in a single beautiful part.

Fit

A steady source of work for any model who can maintain a specific body size is fit modeling, where you are measured by a designer to help them construct garments properly, or serve as a guide for the designer's sample garments to ensure that the clothes have been fitted correctly. It's only necessary that you preserve your measurements (sizes 4 to 14, with size 8 being the most in demand) from session to session — the rest of your look or your age is unimportant. Clothing companies, independent designers, and fashion schools hire fit models on a regular basis.

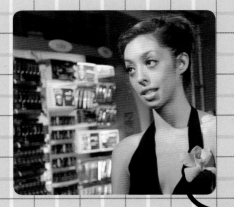

Promotional

Industry conventions and trade shows often use models to display wares and demonstrate products at booths, answer questions about the goods, hand out leaflets and brochures, or walk the trade show floor, garnering attention for specific products.

Types of Modeling

It's important to establish a stunning, unique look for yourself so that you stand out in the world. But it's equally important that you be able to adapt your look to the needs of a particular occasion without losing who you are. Nobody said it was easy!

Your individual look should stem from an honest representation of your own distinctive personality, character, outlook, hopes and dreams, and particular qualities, including representations of your culture, heritage, and background. Your characteristic style should be a beautiful expression of who you truly are inside.

This inimitable, intense personality you express is what will make you more than merely pretty — it's what makes a great model, so that you glow with an indefinable spirit, appearing fully alive and present for the camera.

Study and understand your own look so you can maintain the individual expression of yourself, even when you're adopting different characters to match different situations. The best models are able to mesh their own individuality with the requirements of each modeling challenge, bringing their own strong point-of-view and connecting it to the product or service with charm and widespread appeal.

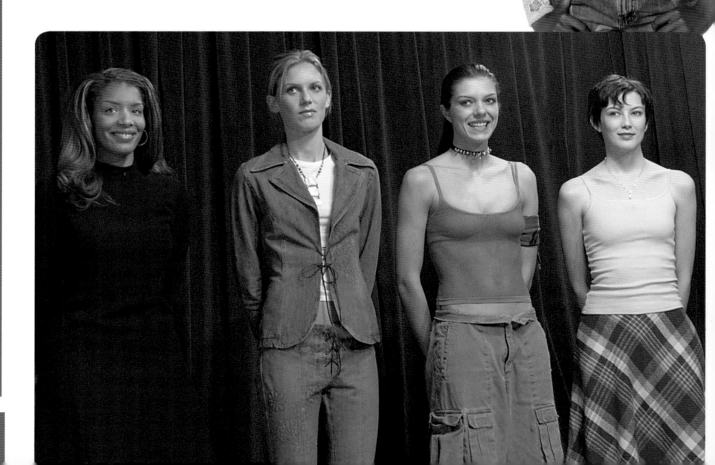

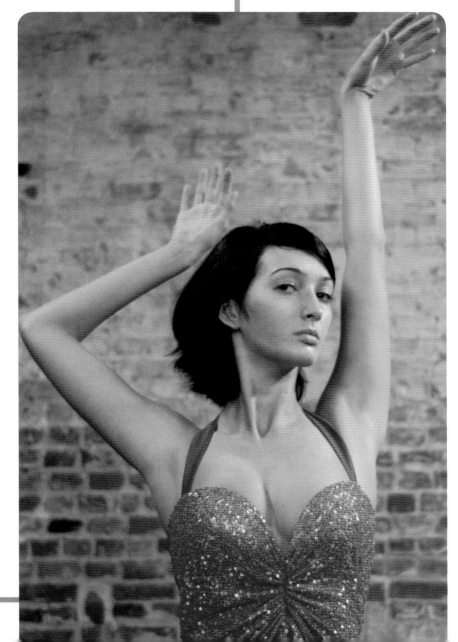

Models know that posing properly with skill, grace, passion, and thoughtfulness is their bread and butter. You must learn and practice the techniques and mindsets of posing for photographs until you're striking poses in your sleep.

The Story

For almost every photo shoot or runway event, the designers and directors will have an editorial concept, an overarching story idea, that they'll want you to convey. Understand the mood they want you to communicate, and then portray yourself as a character in that mood. Some jobs require you to make political or cultural statements, and whether you personally agree or not, you should still fiercely express their point of view. Strive to adapt your poses and relate to the projected audience, but keep your style fashionable, both contemporary and timeless. If you don't understand the editorial concept, ask.

Face First

Focus your energy in your face first, not your body. Relax your mouth, tilt your head toward the camera or audience so that your face is shown to its best advantage, and communicate the proper emotions and ideas intensely with your eyes. Your eyes are your strongest selling point — everything you're thinking and feeling shows through your vibrant gaze, so the deeper you understand the character you're portraying, the stronger your message will come across. You can use emotions from your personal life to connect with the audience, but don't let these thoughts overwhelm you or you may lose concentration. Keep eye contact at all times, even in profile. Commit 100 percent to commanding the attention of everyone in the room, and radiate beauty and enthusiasm for the product.

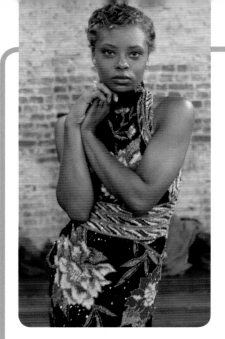

Body Basics

The energy of your body should follow the oomph in your eyes, and the correct attitude for the editorial concept will radiate from within you, no matter how complex the emotions. Be aware of your body language in order to fully inhabit your character, but also create an exaggerated body shape for the camera. Relax your neck, keeping it long and elegant; don't hide the length of your neck from the camera with hunched shoulders or by the angle of your head. Make sure your legs appear elongated and graceful. Even if you have the perfect body, you still need to suck in your stomach and push out your booty!

Cheat the Pose

It's important to learn how to cheat poses, or manipulate the camera to capture the appearance of something different from what you're actually doing. By exaggerating your eye position, you can look at the product and seem to be keeping eye contact with the camera simultaneously. You could also stand in awkward, twisted body positions that feel totally wrong but will look fabulous in a photo. Or you could lean precariously to one side so that your angle suggests the contours of your body through the bulkiest of clothes. Step out of your body and see yourself as the camera sees you. Make adjustments to alter your pose. It's tricky, but if you practice, it can become second nature.

Control Your Shots

Concentrate on the exact facial expression and body shape the camera will capture, but drop your self-consciousness between shutter clicks to grab a moment of spontaneity. Think about your poses, but don't overanalyze your instincts, which could make you appear stiff. Posing is the art of capturing moments. Imagine yourself dancing for the camera, smoothly connecting from one pose to the next, and holding each pose for an intense, focused moment along the way.

Switch It Up!

Always hold a variety of expressions and poses to provide editors with many options. Mix up the emotions to show different, complex sides of the character you're portraying. Don't always give a fierce pose — use your softer side if required. If you've got a naturally hard look, imagine yourself as softer, more approachable, and it should show on your face. Inspire and entertain the photographer with your surprising range of attitudes. Push your poses past your safety zone, digging deep for a moment that appears genuine and natural. It often helps to act in opposition to what your outfit would usually suggest in order to add layers of depth to your pose.

Be Professional

The end product of modeling can be glamorous, but the path to get there isn't always as glam. Work through the pain and don't complain or argue. Maintain the appearance of comfort and high energy even if you're exhausted, nervous, afraid, or feel awkward in skimpy or binding clothing. If you're sick, try to mask it while the camera is clicking. If you feel weak or too uncomfortable, say that you need a second to rest and to adjust to the situation. And no matter how silly the poses may seem, don't crack up laughing. Stay focused!

Love It

While working, always appear as though you love modeling and there's nowhere else you'd rather be. No matter what else is going on in your life or behind the scenes on the shoot, remember how lucky you are to be beautiful, and approach posing with your strongest sense of joy.

Good models are also good actors. It's not necessary for you to be able to maintain a character long enough to star in a movie, play, or TV show, but you must learn the acting skills you need for modeling and for selling products in photos (for a discussion about speaking in public, see the Spokesmodeling and TV Commercials sections.)

Remember that posing is a performance; imagine that you're a silent-movie actress telling a story in a single frame. The better you can find the truth of your role in the scene and express it, the better the product will sell.

While you're posing, don't be afraid to open yourself up and be fully present in the moment. Go ahead and be silly, look ridiculous or extreme, and show a full range of emotion. Realize that people have complex inner lives, so that you must consider your character multidimensionally, without resorting to easy or simple reactions. Fully commit to your portrayal of the character while concentrating on projecting a striking, impressive presence. And enjoy your role — even the dark and ugly emotions.

There are two different kinds of attitude that are crucial for any model to understand and maintain: an intense attitude in front of the camera that shows your fierce beauty, and a considerate, professional attitude when the camera's off.

Daddy, I don't have intensity in my eyes.
— Kelle, Cycle 3

On Camera

The intensity of your attitude while posing is what will allow you to achieve more than just pretty pictures. You must penetrate the camera lens with your powerful vivaciousness. Stare right through the lens, reaching out to contact the audience and connect to them with your gaze. Always be fierce, but adapt your attitude depending on the outfit and the needs of the client. You need to find the right attitude for the exact product you're selling.

If you've been hired as a model, you can be sure that you're already pretty enough to look ferocious and ugly if the scene requires it — but make sure that it is a posed, intense ugly, and not an accidental ugly. Express the extreme, but make it appear effortless.

Off Camera

Save your bad attitude for the photos. Always appear strong, even if you're crying or miserable on the inside. Avoid constantly giving excuses for unprofessional behavior. Handle criticism without crying or whining, and have enough courage to swallow your fears. Believe in yourself so you'll have enough confidence to deal with rejection.

Being a model takes a huge amount of commitment, self-discipline, and self-confidence. Yes, you're gorgeous, but remember that a photo shoot is not about you — it's about the client paying a photographer, stylists, and you to create photographs that will sell their product. If you looked beautiful on the shoot but didn't fulfill the client's requirements, you didn't do your job.

Most of all, as a professional on set, make sure to become friends with the editors, photographers, and stylists. Impress them with your good humor, willingness to work, intelligence, and upbeat attitude. Don't purposefully give anyone reason to dislike you. As in every other industry, you'll get rehired based on your work, yes, but also on the quality of your relationships with your coworkers. Give them good personal reasons to want to hire you again!

There's almost no product on the market for which a certain amount of sex appeal won't increase sales. Certainly, the fashion industry thrives on images of classy sexuality. Its your job to apply your own sense of appropriate sexiness to you life. Use your body, but keep the real sexual energy coming from your mind. Always remember that your sexiness is a fantasy, so the stronger your internal confidence comes across the more people will sense it. It's you who is sexy, not the outfit.

While sex definitely sells, be very aware of the fine line between sexy and sleazy. Don't overdo your sexiness, or you'll end up looking like you're working for a pimp! Keep your sexy side mysterious, intriguing, and sensual — not trashy.

Know Your Audience

The sexiness you project should be tailored according to whether you're aiming for a male or female audience.

If your product is meant for women, you should strive to project a softer, sensual sexuality, with strong emotional content. Show your sweet, dreamy side, and stay graceful, as though you're starring in the most romantic movie. You ultimately want your female audience to identify with the character in the stimulating fantasy you're portraying.

If, for example, you are doing a layout that will appear in a men's magazine for a largely male audience, you should direct your sexiness in a more obvious, hot, and seductive way. Here's your opportunity to let your lustful side out, although you should look more available than slutty. Don't confuse looking mean with looking sexy — don't wrinkle your nose or squint, and keep your lips pursed. Push out your booty and bust. Imagine a hot guy in your mind and let him know you want him with searing eye contact through the camera.

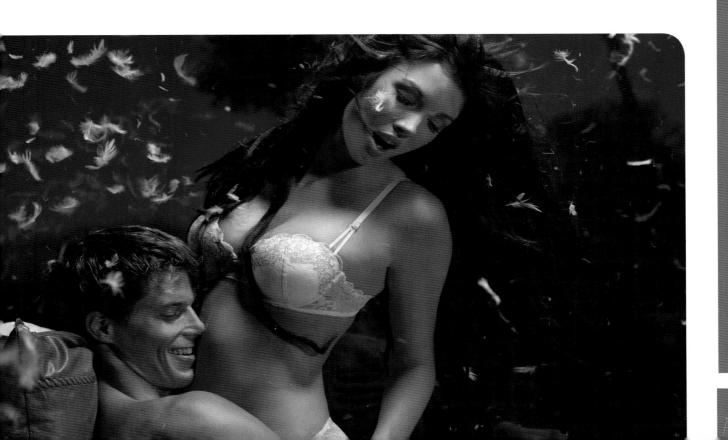

Practice

There's only one way to become fierce, and that's to practice constantly and consistently. Every good model spends time practicing in the mirror on a regular basis, working on perfecting her facial expressions and body poses until she can perform them automatically on demand.

You're not going to have a mirror to check your poses, so while you're practicing, concentrate on how your body and face feel while you're holding a look. When practicing in the mirror, you should focus on two goals: to find poses that show off your face and body to their best advantage while expressing a variety of emotions, and to physically remember the pose with your muscle memory by repeating it until it becomes second nature so you'll be able to flash it with no self-consciousness.

Flip through the newest fashion magazines for expressions and poses, and notice how the models hold themselves in various clothing styles. Copy their poses in the mirror, adding your own twist to make the looks your own. Experiment with expressions that really hit the truth of different emotions, and attempt a range of poses for all occasions.

While you're practicing, be critical of your work, but keep your thoughts constructive and positive. You may be awkward or rusty at first, but keep at it, and remind yourself that you will improve. Remember that nobody has a perfect body or a perfect face, and you're putting in all this practice to make yourself a better model. Pay close attention to how you're holding your hands in the poses, since what you do with them is often a telltale sign of nervousness or discomfort. If you've received any critiques about your posing, focus on fixing those issues first.

Some models find it helpful to practice posing in the mirror while naked, because once you're confident in your ability to look fierce and fabulous totally nude, you can make any outfit seem spectacular.

When you're on a photo shoot, you'll want to be concentrating on the story line that the editors have chosen. The more ease you feel about reaching into your bag of tricks without hesitation for instant emotional poses, the smoother the shoot will go and the more depth of personality you will display.



Rather than in the controlled environment of a studio, your life, like many photo shoots, is set in a variety of indoor and outdoor locations. The resulting images are often deceptive — what looks like a glamorous place in photos can often be quite misleading, like a grungy back alley faked to look like a corridor in a palatial castle.

On Location

Be ready for anything while shooting on location. The shoots can be fascinating, exhausting, fun, embarrassing, disorganized, disastrous, or really, really boring, and as a general rule, anything that can go wrong will. Props can be forgotten, places are sometimes double-booked — all kinds of plans go awry, especially in outdoor locations, where the weather is unpredictable. Do your best to prepare for any situation, and be a good sport about putting in your best effort even during the most difficult of circumstances.

Never, never be late for the start of a shoot, because time on location is expensive, and expect to stay later than you were told. Models end up doing a lot of waiting for the shot to be set up and are then forced to rush to do theirs job professionally in the shortest amount of time possible. You must move fast to get all the shots done, or to take advantage of the sunlight needed for the photos to catch the particular effects of different times of day, such as the "magic hour" right before sunset.

Expect to have very little privacy on location for changing clothes, and remember to think warm while shooting on cold outdoor sets, or think cool when you're posing in the sizzling heat. You shouldn't wear perfume when modeling at any time, as it stains and lingers on clothing, but you should never wear it outdoors, as it attracts bugs, including bees.

To avoid squinting while posing in blinding sunlight, close your eyes for a count of three and then pop your eyes open into a perfectly composed expression.

Props

Occasionally, models are called to pose against a plain backdrop, in real life, but more often, in real life, you're likely to find yourself in environments with props — objects to interact with — and a background to consider. Props include furniture, cars, products, and other people. Make sure you don't get overwhelmed by your costars or the surroundings — stand out as the main focus and try to pull all the attention to yourself.

Remember that you're creating an illusion of reality, so interact with everything around you so your poses appear natural. Let the props inspire you to get in the mood and bring the world you're portraying to life more fully with you as the main character within it. This is a great time to get creative with the objects, playing off the product and other things around you. The more imagination and experience you bring to creating the illusion, the more your audience will be drawn into your story. You could even react to the wallpaper or the shadows around you if it's appropriate.

Holding props not only brings the scene to life, but it also gives you something to do with your hands while your posing. Don't forget that you should be showing off the product to its best advantage, so don't obscure it or ridicule it in any way.

When working with other models, strive to ignite the connection between you so that the audience immediately grasps your relationship in the story line of the shoot. Chemistry with other models is a hard thing to fake, and all your acting skills will be tested, but try to be as natural as possible and go with the flow so that you can achieve spontaneous and honest reactions. If you're doing your own styling for a shoot, make sure your clothes and makeup coordinate flawlessly with the other models' looks.

Both high-fashion and commercial modeling, especially catalog and men's magazine shoots require models to look fierce and fabulous in swimwear and lingerie. If you're under eighteen, it's inappropriate for you to model swimwear or lingerie for anyone. All clients should be aware that it's improper to ask underage models to pose in skimpy outfits.

If you're going after swimsuit or lingerie jobs, make sure that your body is in incredible shape. It takes determined dedication to achieve the kind of muscle tone and perfect silhouette to emulate models. Any excess flab on your physique is going to be highlighted in the extreme, so only the fittest need apply. For most swimwear and lingerie advertising campaigns, it also helps to have a certain girl-next-door quality, and a larger bust size.

Of course, the biggest advantage you can have for modeling swimwear or lingerie is supreme confidence in yourself. You must feel absolutely sure that you look amazing while you strut your stuff wearing nothing

Swimwear & Lingerie

more than a few strips of stretchy waterproof fabric, lacy undergarments, or a diaphanous negligee. Your confidence will show in your eyes, so make sure you keep your gaze fierce with assured certainty in your beauty.

When you're posing, be very aware of the shape your body is making for the camera. Emphasize your curves, especially your buttocks and breasts, and arch your back for a lean, sinuous pose, while never losing the confident and intense connection that your eyes have with the camera.

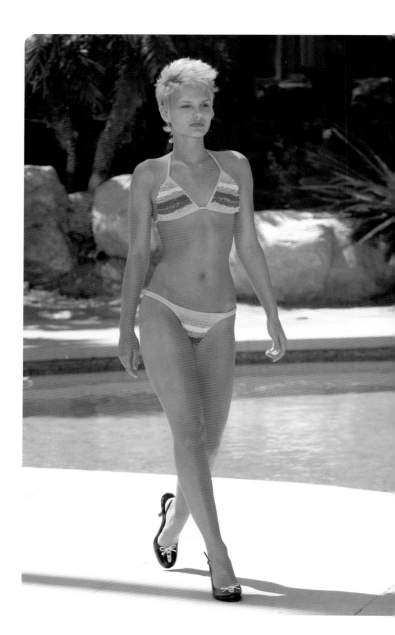

Not everyone is comfortable with nudity, and unless you're posing in an art studio or working in the glamour modeling industry, allowing yourself to be photographed naked in any revealing position should be carefully considered. For many nude photo shoots, the aim is an illusion of nudity, so you can some-times get away with wearing skimpy, flesh-color garments or body suits if you can't handle being fully naked on set.

Like modeling swimwear and lingerie, you must be over eighteen to model nude.

However, every model should be comfortable being naked in certain situations when the camera isn't clicking. You'll often be called upon to change clothes where there's very little privacy. For instance, backstage at a runway show, there isn't time to hide behind a screen in the two minutes you have to switch outfits, and you may find yourself being naked backstage with 30 other girls in the same situation.

If you feel too uncomfortable with being naked, or believe it compromises your values, do not apply for jobs that require it, rather than surprising the photographer with a refusal when you arrive on set.

When you're posing naked, the expression in your eyes must be heightened even more than usual, and be hyper aware of the positioning of your body. Strive to stay comfortable with yourself at all times, so that you shine on set.

There are four basic kinds of nude modeling: suggested, glamour, artistic, and erotic. With suggested-nude commercial and fashion modeling, nothing revealing is actually shown, and the nudity is an illusion used to sell a product such as perfume. Glamour modeling is more revealing, with an emphasis on playful or sexy poses, like in men's magazines or pin-up

calendars. Artistic modeling can be fully nude, but the focus is on the art of photography itself, not the desire of the audience, and it's often in black and white. Erotic modeling is more sexually artistic modeling, while still remaining non pornographic.

You know what, Jay? I think I'm more comfortable naked.

— Dionne, Cycle 8

That's . . . uh . . . interesting.

— Jay Manuel

Runway shows are performances developed to showcase a fashion designer's clothing for the industry and media, and they are indeed shows — a kind of wordless theater set to music. As a model in a runway show, or walking down the street or hallway looking like one, you must play a role with pure conviction, matching our personality to the concept of the event, adapting your own walking style to fit the overarching editorial idea and complement each individual outfit. Show off the clothes like they are pieces of fabulous art you're thrilled to be wearing.

My motto is: Walk like it's for sale and the rent is due tonight.

— J. Alexander

Show Off Your Skills

Great runway walking is a high-level modeling skill, and it requires focused precision, fierce attitude, poised gracefulness, and excellent posture. While maintaining the persona of the character you're portraying, concentrate all of your energy on creating an intense aura of beauty around you, while remaining relaxed and centered. Don't appear uptight or stiff! Imagine wind blowing into your hair as you walk, and if you perform with enough sass, you'll even seem to be creating your own wind-blown style.

You want to always glow with a classic sexiness, and avoid seeming too formal and rehearsed, which can translate as pageant princess. A standard in the industry is to walk with a pissed-off expression on your face. Learn to perform a style of stepping called "The Stomp," which is achieved by dropping your hips as you walk and solidly connecting your heels with the floor. Don't forget to keep your hands relaxed, and walk forward with long steps to keep up with the pace of the music.

Hold your neck up in an elegantly relaxed posture, and keep your eyes focused straight ahead, occasionally zapping audience members with the fierce connection of your gaze. Don't let your head bobble as you walk!

Don't fall or trip, but if you stumble, get up and hit a pose again, acting like nothing happened. Never show your mistakes — make accidents look like they're deliberate, like part of the show. Don't crack under pressure!

To really boost the drama of your runway moment, slowly open clothes, like jackets or wraps, while you're walking, and remove outer layers to stunningly reveal the beauty of the outfit underneath.

Pose Perfect

At the end of the runway, stop in a solidly posed position, showing off your garment so that it wows the audience. Snap, crackle, and pop that pose! Then smoothly swivel around and return up the runway, showing off the back of your outfit with just as much of a feisty attitude. Don't drop your character when returning up the runway!

If you're performing with other models in a synchronized group routine, be extremely aware of the position of the other girls on the runway, and remember your choreography.

Most of all, practice your runway walk constantly so you can stomp the catwalk with incredible confidence and skill.

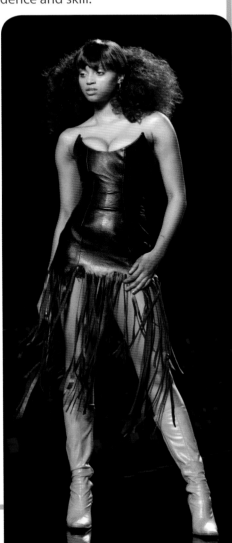

HELPFUL HINTS:
Walking in Heels

Step into your high-heel shoes and make sure the fit is secure — better a little tight than too loose. Start practicing with short steps on a flat, non slippery surface, then work up to longer strides on different kinds of floors. Balance yourself firmly on both feet with your weight centered between the balls of your feet and your heels. As you start walking, shift your weight to the balls of your feet and push up from the ball as you take a step. Come down on your heel and quickly but smoothly follow up by rolling your whole foot onto the floor, and then hold your weight between the ball of your foot and your heel while you shift your other foot back to the ball to take the next step. Your toes should always point straight ahead. To help maintain your balance, swing your arms as you walk. Keep your legs straight and close together, and hold your torso upright, without leaning too far forward or backward.

While walking on stairs, always keep a firm grip on the banister and step carefully!

Spokesmodeling

Experienced models with good speaking voices and sparkling personalities sometimes get the opportunity to be spokesmodels, either as correspondents or interviewers for a TV show, or as presenters or hosts at live events such as trade shows. In any kind of situation in which you may find yourself, like giving a toast or making a speech, remember the script or the points you need to hit while presenting. Let your natural, unique personality shine, don't act like you're putting on an affected role, and stay on topic.

Correspondent

In stand-up talking-head speaking, you're trying to present more than just a pretty still picture, so focus on making your speech as conversational as possible. Imagine you're talking to someone because you are except with an audience watching. Speak eloquently, but also like you're in dialogue with your best friend, not like a robot reciting the facts or like you're reading. Stay poised, and don't frown when you're speaking. Relax your forehead, and smile, keeping your energy cheeky and upbeat.

Interviewing

While interviewing someone, stay confident and engaged in the conversation. Don't be a chatterbox yourself — keep the attention on the interviewee — but don't be too quiet, either. To get the interviewee talking, ask about some anecdote concerning the subject at hand. Make sure he or she answers the question you asked. To switch subjects after the answer is complete, take the last phrase the interviewee said and twist it cleverly into a segue. No matter how much an interviewee annoys you or gets combative, stay cool, composed, and friendly.

Live Presenting

The needs of live presenting are very similar to being a correspondent, except that you're addressing a live audience, not speaking to them through the distance of a TV camera. Stay attuned to the energy and reactions of the live audience, and adjust your approach based on their immediate feedback. Remain energetic and cheerful at all times, answer all questions politely, and don't forget to hit all the product points you've been given by the client.

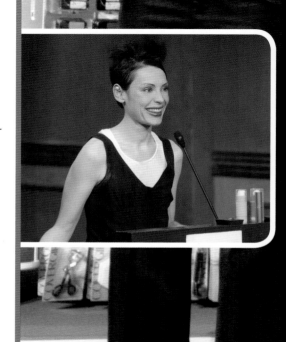

A lmost everyone has a TV at home, so modeling in a television commercial is a way to achieve amazing national exposure. Commercials are often scripted as thirty-second-long dramas or comedies. They set up a problem for the characters and then solve it with the product that's being featured.

When you read the script, keep the product being sold in your mind, because everything is set up to highlight its greatness. Ask yourself what the perfect mood and attitude would be to accentuate the product, and don't hesitate to discuss the approach with the director. Listen carefully to the director's comments and suggestions, and make sure to get into the mood that the script requires, whether it's funny, cheerful, confused, poignant, sad, or whatever other emotion necessary. Memorize the script!

Work on your timing so that you deliver the lines with snap and polish. Remember all the choreography, steps, and position marks on the floor to hit in front of the camera. Stay positive and energetic so you don't sound forced, and keep a strong look of confidence in your eyes. Don't judge yourself too harshly while you're performing, or nerves will take over. Let your personality shine.

Enunciate all your words clearly and project your voice without shouting to give the script the full force of your personality. Even if you don't use the product in your real life, never for a moment let that show — you must sound like a true believer! You've also got to deliver your lines in a spontaneous, natural way, as though you're truly in the moment and talking to your best girlfriend. React naturally to the other actors in the scene with you and listen intently as they deliver their lines.

Don't forget that acting in a commercial is not the same as posing for a still photograph — a TV camera captures motion, so keep busy at all times with believable movement that stems from an honest place within the scene.

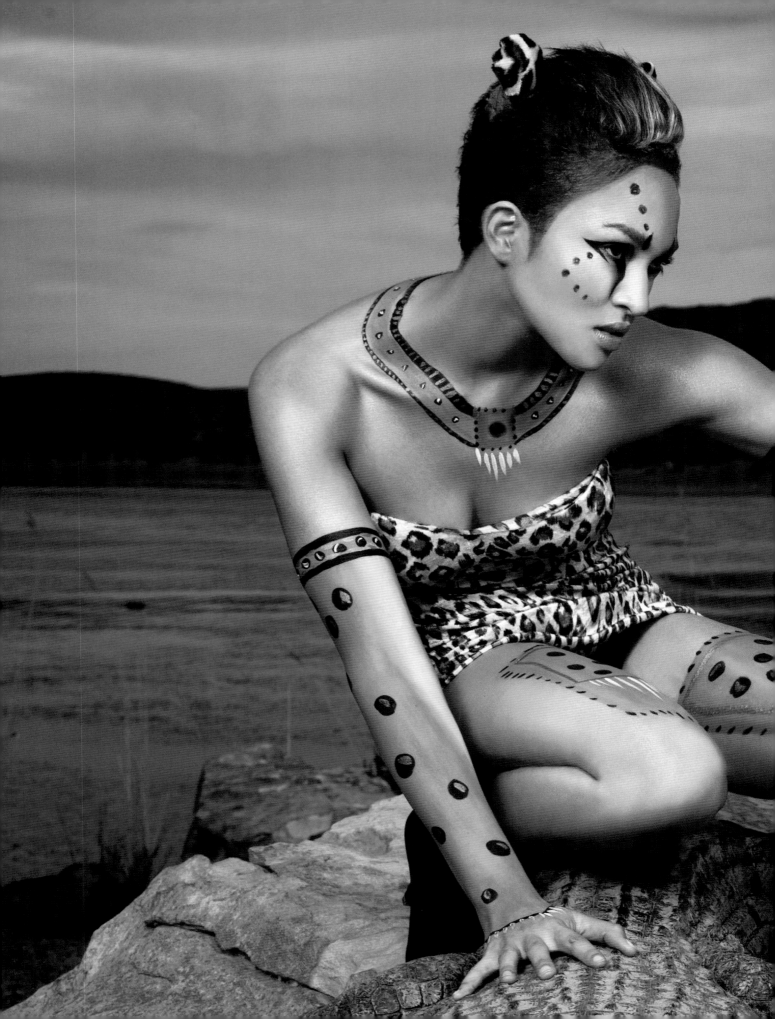

NEW

Lubriderm
SKIN NOURISHING
Oat

Business

Modeling is a business, and you — with your beauty, talent, skills, and savvy competence — are the commodity you're marketing. To behave like a successful model or any professional, you must take charge of your career, whatever it may be, and learn how to promote yourself, behave professionally, take care of your money, make smart connections, and avoid pitfalls.

Get Organized!

Even though a spacious living area is often difficult to come by, set aside an area in your home with a computer and file cabinet so you can track the details of your business. Keep a log of your auditions, interviews, go-sees, and gigs — both successes and disappointments — and note the names of the agents, editors, clients, designers, producers, photographers, stylists, directors, publicists, reporters, coaches, trainers, and others you meet. Don't keep your industry contacts only in your cell phone — maintain a file of the people you meet on your computer, and hold onto all business cards. Each new connection opens a new door to your career, and you don't want to lose any opportunities.

Make sure you record all financial dealings, no matter how minor, so you can monitor your income against your expenses, gauge the growth of your business, and be prepared for tax time.

Have Faith!

No matter how tough it gets in your pursuit of a career, if you believe in yourself, you can courageously continue to keep chasing your dream with determination. Don't quit — keep pounding the pavement, knocking on doors, and persistently arranging meetings. Don't give up until you're the success you always dreamed you'd be.

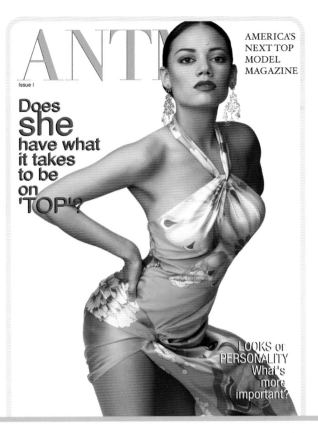

ANT

Issue I

AMERICA'S NEXT TOP MODEL MAGAZINE

Does **she** have what it takes to be on 'TOP'?

LOOKS or PERSONALITY What's more important?

Models know that you've got to make yourself into a unique commodity, so that your name, style, and fierce individual beauty become a brand. The more strongly your distinctive features and characteristic flair become associated with your name, the more powerful your brand will be, and the more opportunities you'll get.

It helps to have a unique name. Don't be afraid to create a memorable new persona and name for yourself if the one your parents gave you doesn't sound chic. Remember that your new handle should stem from who you really are and what you honestly represent so you don't come off sounding like a pretentious poseur. Lesley Hornby was advised at the age of sixteen to use her childhood nickname, Twiggy, and that memorable name perfectly represented her radically waifish look, dramatic eyelash makeup, and gamine humor. All of these traits properly branded helped focus her career and catapult her into stratospheric modeling stardom.

Even when you're not on a job or going to an audition, always present yourself as a model decked out in your own personal style — never appear anywhere in public when you're not prepared to be photographed by surprise. Paparazzi may be lurking at any time, and in this age of cell phone cameras, you can be snapped by anyone and not even know your picture was taken until it appears on a blog with a mocking commentary. They'll always pick your worst photo, which can be awful publicity for your beauty brand. Develop almost a sixth sense about a camera being pointed in your direction, and always be aware of the image you're presenting, even when you're just running out to pick up skim milk at the corner store.

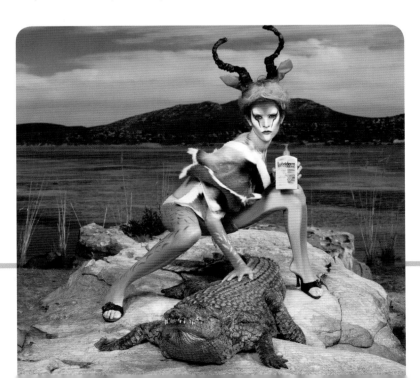

Model Behavior

You must maintain a high level of pleasant professionalism at all times. Frankly, a lot of people in the fashion industry, and a lot of other businesses, can be fake, but try to get along with everyone and be as gracious and kind as you can without being a pushover. Think of other women as your sisters, and be a little sister to the veterans and a little sister to the newcomers.

A girl who hangs up her own clothes is better loved. I hate those bitches who just throw them on the floor!

— DSquared

fierce, not furious...

Be on time!

Strive to arrive early for an interview, go-see, or show. You should know exactly what you're required to bring to the appointment in terms of resume, clothing, props, or styling products in advance, and don't forget any of it. Even if something unusual occurs, avoid taking off early. Breaks, including lunch or other meals, should be discussed before you report for the job.

Go alone.

It's inappropriate to show up with your friends or significant other, and only bring a parent if you are underage. Never gossip about your auditions, gigs, or earnings to anyone.

While you're on a job, don't smoke, drink anything but water, eat, or chew gum.

Bring mints to keep your breath pleasant. Only use your cell phone for serious emergencies, and keep all calls brief. It helps to bring a book, because there's always going to be downtime.

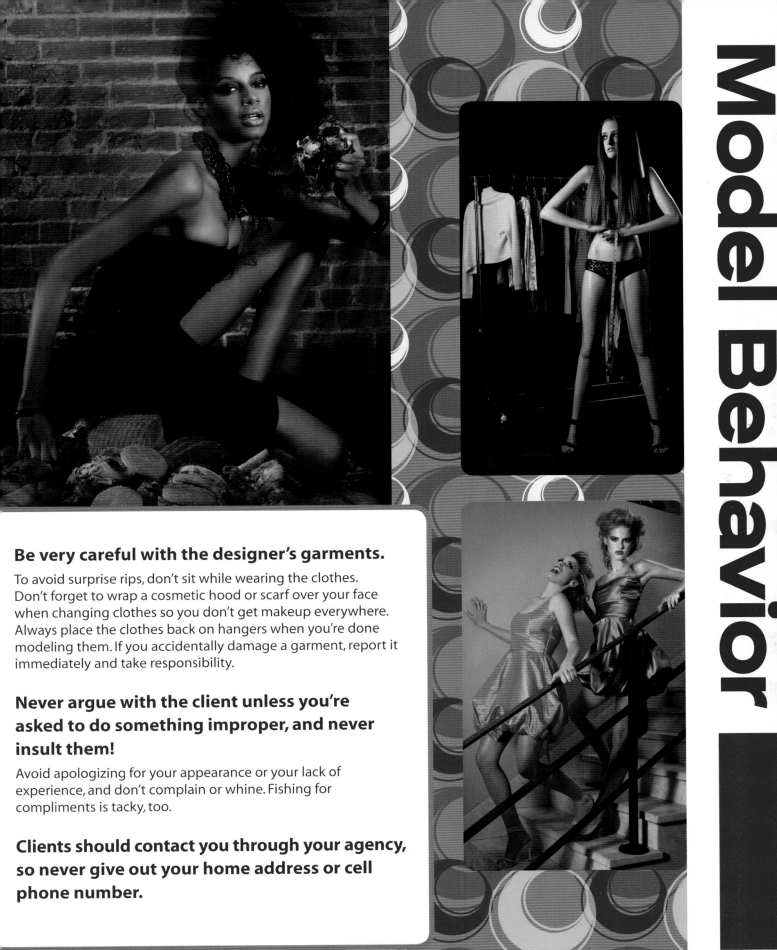

Be very careful with the designer's garments.

To avoid surprise rips, don't sit while wearing the clothes. Don't forget to wrap a cosmetic hood or scarf over your face when changing clothes so you don't get makeup everywhere. Always place the clothes back on hangers when you're done modeling them. If you accidentally damage a garment, report it immediately and take responsibility.

Never argue with the client unless you're asked to do something improper, and never insult them!

Avoid apologizing for your appearance or your lack of experience, and don't complain or whine. Fishing for compliments is tacky, too.

Clients should contact you through your agency, so never give out your home address or cell phone number.

Only the most successful top models make enough money to allow them to model full-time, so prepare to have another job to pay the bills, or stay in school unless your career really takes off. Remember that most models only have a career that lasts less than a decade, so consider what you're going to do with your life when your modeling window closes.

Payment rates are lower for inexperienced models, but as you become recognized and requested, the money per job can increase significantly. It all depends on how much demand there is for you in the industry.

The standard commission for most agencies is 15 percent to 20 percent on all your earnings. Agencies may expect you to pay for all paperwork, printing, and mailings, although they should never charge a registration fee.

For every gig you get, go prepared with an agency voucher for the client to sign, and return your voucher to your agency within a day after the job is done.

Many modeling agencies do not withhold taxes from your paychecks, so it's important that you find a great accountant, one who is familiar with the modeling industry, so you don't get shafted at tax time. You may also be responsible for getting your own health insurance.

For every audition or go-see, bring your modeling portfolio with you. Your portfolio — also called your "book" — represents you, so make sure it looks neat and professional to make a positive first impression. You can audition for agencies with a few good snapshots, but after that, fill up your portfolio with professional photographs pronto! Remember that if you work with fabulous photographers, you'll get fabulous pictures.

A typical model's portfolio is 9-by-12 inches, so that you can fit larger tear sheets and 8-by-10 inch photographs in it easily. Always keep your photographs protected in plastic pages, clipped into your portfolio binder. In the back of the portfolio, keep a few of your composite cards, and a sheet of great slides. Do not put anything else in your book.

Your portfolio should contain between six and 20 pictures of you, in a variety of poses, with a mixture of close-ups of your face and full-body shots. The pictures should show the type of modeling you want to do. If you want to be a swimwear model, don't have high-fashion pictures in your book — have swimwear shots and vice versa. Show versatility, but only in the kind of modeling that suits and interests you the most.

Make sure that you can justify every photo in your portfolio — be vicious about maintaining quality over quantity. One mediocre picture can cost you a job.

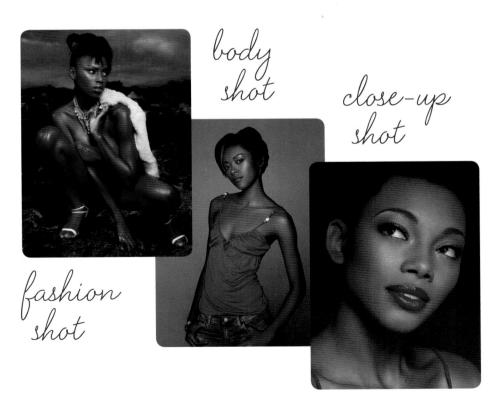

body shot

close-up shot

fashion shot

A composite card, or "zed card," is a small version of your portfolio that you can leave behind with the client when you're finished with a go-see. It serves as your business card, and your agency may mail your cards out to potential clients. Often a client makes the decision to hire you days, weeks, months, or even years later based on your composite card. Slip a few comps in the back of your portfolio, your purse, and your tote bag so you'll always have them with you in case an opportunity arises to give one to a potential client.

Your agency will help you organize your composite card and have it printed. The typical zed card is 5.5-by-8.5 inches and has your best photo on the front and up to five small images on the back. Your name should be printed on the front and your measurements as well as the name of your agency should be listed on the back.

The small pictures on the back of the composite card are there to show your versatility, so be sure to include a variety of shots that reflect who you are as a model.

Get a new, updated composite card every year so that your pictures always stay current.

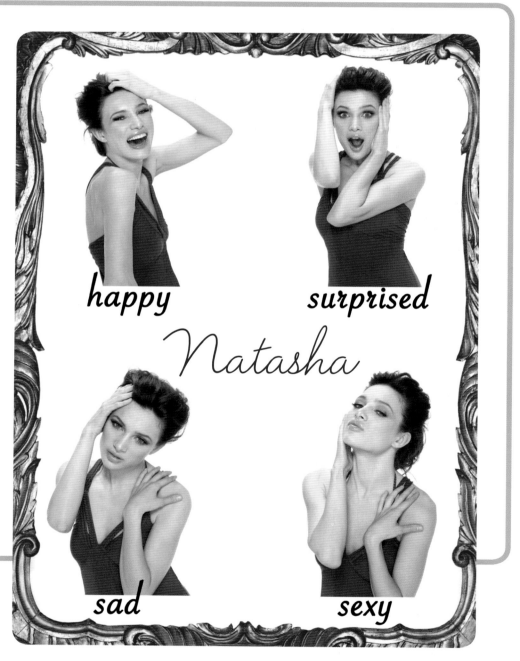

happy

surprised

Natasha

sad

sexy

A go-see is the modeling industry term for an appointment arranged for you by your agency. Like all interviews, it is an opportunity for you to audition for clients, such as designers, advertising agencies, magazine and catalog editors, photographers, art directors, or casting agents. Your agent will provide you with a list of the names of the companies and clients, the times you should arrive, and the types of modeling you should expect. You might spend your whole day going from one go-see to another.

Be organized — make sure you know how to get to the address of the go-see, and don't lose your list. It helps enormously if you do your homework and research each client beforehand so you're not hit with any big surprises. Be on time! Call if you're going to be late, but don't expect the job to be waiting for you. For go-sees, wear clean, conservative clothing and go easy on the makeup. You're presenting yourself as a beautiful canvas onto which the client can project their product.

Your audition begins the moment you enter the room. You have about two minutes to impress the client enough to book you, so impress them immediately, showing how your fierce individual look could be adapted like a chameleon to their needs. This is the best time to express who you are rather than merely telling them what you have done. Answer questions honestly and completely, but politely. Project a friendly personality, and show energy, charm, warmth, and confidence, no matter what your mood was before you arrived.

Ask the client to describe their editorial vision, their concept for the clothing line, and then imag-ine yourself in their layout or commercial, so they can imagine it, too. You may be asked to walk, pose for test shots, or try on out-fits. Love everything about the product they show you, and act comfortable in the clothing. Take direction professionally, and pose and walk in the clothes in a style appropriate for the outfit.

The odds are that most go-sees will end in rejection, but don't take it personally — the client might have had a different look in mind.

After the audition, always record the name of the client, the type of product, and whether the go-see was successful or not, for future reference.

HELPFUL HINTS:

Model Tote

Always arrive at photo shoots prepared for anything. The best way to do this is to bring a carefully packed tote bag with you to every shoot. Not all the things on this list will be necessary, but always think about what you should pack for the type of shoot that you are doing that day.

- Bottled water
- At least one change of clothes
- Your modeling portfolio and composite cards
- A makeup kit with your colors
- Nude and black pantyhose
- A washcloth or towel
- Soap and facial cleanser
- Toilet paper, tissues, and baby wipes
- Eye drops
- A mirror
- A toothbrush and toothpaste
- A hairbrush, hairpins, and hair ties or bands
- Tampons
- Dress and panty shields
- A lint brush
- A pair of scissors
- Nail clippers and polish
- A small first-aid kit, including adhesive bandages, and aspirin or ibuprofen
- Hairstyling products

On a shoot as a model, you are on the bottom of the food chain. You'll be taking direction from editors, clients, art directors, photographers, stylists, and agents. You shouldn't argue; although you are a very important part of the creative process, your creativity is limited to breathing life into the existing concept in surprising ways.

It is of the utmost importance that you treat everyone on the set with respect, especially the stylists and photographer, who are your collaborators in making beautiful pictures. Always keep the conversation warm but professional, and avoid criticizing the efforts of others. The best photographs are taken in an atmosphere of friendly mutual respect.

When you're done with your work for the day, always ask the photographer or shoot director for tear sheets so you can include them in your portfolio.

Without an agent, it's so difficult to find modeling work that it's almost not worth trying. Clients approach the agencies when they need models, and they go to specific agencies to find models of the type that they typically represent. Each agency has a brand it scrupulously maintains, so its models are extensions of its image.

Research agencies to discover the ones that best fit your individual look and style. You can contact agencies directly and ask if you can visit their offices for an audition, but they may ask you to wait for an open call.

An open call is when an agency interviews dozens or hundreds of wannabe models at once. Open calls are almost always free. You visit the agency with all of the other models, and it seldom takes more than 30 seconds for the pros to size you up and decide if they want to represent you. Don't be discouraged if you don't get picked by the first agency or by the first ten you visit. Try them all!

For an audition or an open call, dress casually in flattering, well-fitting clothing so that the agent can see your body. Keep your hair conservative and your makeup natural, presenting a blank canvas. You don't have to

already have professional photos; just a few snapshots are fine. Bring photos that show your full body from various angles both casually clothed and in a swimsuit, and at least one beautiful headshot. Expect to leave your photos with the agency.

If you're fortunate enough to catch the agent's attention strongly enough that they agree to take you on as a model, the agency will arrange for you to have professional portfolio pictures taken and a composite card printed.

Legitimate modeling agencies do not charge registration fees, or require that you pay their photographer to shoot a new portfolio for you. Make sure you read your contract carefully. Beware of contracts that limit you to exclusive representation until you're sure the agency will book you enough work. It's a good idea to have your own lawyer look over any contract before you sign it.

Scams

You should never have to pay someone to tell you if you have what it takes to do your job. Remind yourself that you're trying to make money, not to give it away. There are many kinds of scammers out there who prey on the hopes and dreams of wannabes, so beware!

Phony Photographers
Watch out for photographers who try to get you to buy expensive portfolio pictures before you approach agencies. You can bring personal snapshots to any agency audition, and if you're hired, the agency will arrange your portfolio photography. The agency should not require you to pay to use their exclusive photographer.

Modeling Conventions
While a modeling convention might be a good way to learn about the industry and do some basic networking, they're expensive and rarely result in getting hired by an agency.

Registration Fees
If an agency requires you to pay a registration fee before they consider you as a model, contact the Better Business Bureau hyperlink http://www.bosbbb.org/lit/0127.htm to see if there have been any previous complaints. Agencies that charge registration fees often aren't surviving by their modeling commissions alone, which means that you won't be able to survive, either.

Modeling Schools
You don't need to go to modeling school to become a successful model. In fact, top agencies prefer that you didn't pick up the outdated thinking and bad habits that some schools teach.

Sleazeballs
If someone demands that you pose naked in order to get hired, you're dealing with a sleazeball, and you should try again elsewhere. If someone tries to get you to trade sex for work, call the police.

Bad Businesses
Some smaller modeling agencies are legitimate enough, but they're just not run by experienced or talented businesspeople. If you're taken on by an agency that doesn't have good contacts to send you out on enough go-sees, or if they mismanage your money, it's time to move to a better company.

Advertising
Beware of agencies that advertise, especially ones that guarantee work or claim that anyone can be a successful model. The good modeling agencies are already overrun with potential models. If they are short of talent, they'll send out scouts, not advertise. The exception is that sometimes open calls are advertised in trade magazines.

To be a success, being liked, even loved, is simply good business practice. All excellent businesspeople strive to grow their network of contacts. Every time you work with someone you are building your reputation. A good impression has great effect on your career, since former associates will want to work with you again, and are likely to refer you to others. Remember, though, that a bad impression has the opposite impact — and a negative evaluation has a much bigger ripple effect on your life.

You've got to hustle and network.
— Eva, Cycle 3

social butterfly

Don't be afraid to ask clients you've enjoyed working with for referrals, and if you are recommended by someone, always give credit where credit is due. If you didn't enjoy working with a client, be professional and never burn your bridges as it only harms you.

Every party or social event you attend is a chance to network and impress potential clients. Bring your comp cards with you, and put yourself out there. Don't act crazy, and don't bother celebrities, but it's better to be talked about than not noticed at all.

HELPFUL HINTS:

Twiggy's Networking Rules

- Be eloquent and express yourself clearly.

- Don't monopolize conversations.

- Use humor. Be witty but not over-the-top.

Most agencies will already have a publicist, but once your career and financial situation gets to a certain level, you may want to consider hiring your own personal publicist. Publicists are not necessary for every successful businessperson. You will only need a personal publicist if you really want your growing fame to reach stratospheric levels. They handle requests for appearances and interviews, build buzz, and work to brand your name as a celebrity.

Paparazzi

As you begin to achieve fame, you will have to deal with paparazzi. Keep your wits about you, even though it can be scary to be mobbed by the press. Remember that to the public, perception is reality, so always look your best whenever you're out and about. And always wear sunglasses so they don't know where you're looking.

Interviews

Giving an interview can boost your profile enormously, but giving a bad one can sink you, too. Understand the journalist's concept for the story they're trying to tell, and if he or she doesn't have one, supply one! Give your real opinions and show your true personality. If you've done something bad, come clean honestly and don't try to hide the issue as the truth always comes out. Remember that the public is forgiving. Being a celebrity model is like being one of the popular kids at school. The public likes to break down famous people, but they also love a great story of redemption.

While you don't have to have a PhD for every job, it helps to be intelligent, imaginative, and interested in the world; school will help you reach a higher potential. You should at least finish high school, because, for example, after your short-lived modeling career is over, whether you're successful or not, you'll be happy to have other options. The best years in a model's career are the same years most students attend college, and many models pay for higher education with the money they've earned modeling.

It is crucial that you are completely informed about the fashion industry. Research and familiarize yourself with all the types of modeling, especially the ones for which you're most suited. You should make yourself an expert on the whole business, including the designers and models both past and present, as well as familiarizing yourself with photographers, magazines, and editors. Learning about your favorite models' successful career paths is a great way to get inspired and to figure out your own direction through this difficult industry.

It also helps if you understand the basics of photography. Keep watch for photographs that you love in magazines, note who took them, and figure out what makes the photos so special. Then you can accentuate the techniques you've noticed while you're posing.

If you're aiming for fashion modeling where runway work is required, it doesn't hurt to take a catwalk workshop, but otherwise, you need not attend a modeling school. You'll get the experience you need through practice and while working. If it's necessary for you to learn a specific skill, your agent can arrange for you to work with a coach or trainer.

Acting skills help enormously with commercial modeling, so acting lessons or workshops may help you express a wider range of emotions in front of the camera.

Modeling is an international business, and to live the model lifestyle, you must be prepared to travel the world. Traveling is a blast though, and nothing will broaden your horizons more than immersing yourself in another culture. Don't forget to adapt your attitude to the standards of different countries, and it also helps to learn other languages!

Travel light for short trips, and only bring one carry-on. If you're booked for a longer stay, bring only one suitcase. You never know how much you're going to need in order to move around, and you may not have help getting from place to place.

The foreign apartments for models just starting their careers are cramped and tight, so don't expect to be staying anywhere palatial when you're first starting out.

Look your best on the plane, and freshen up in the restroom before you arrive, because sometimes you'll need to go directly to the location of the photo shoot, without any time in between to sleep, shower, or change.

When you're hired for a foreign gig, check with your agent to see if you need a passport, visa, or working papers before you leave.

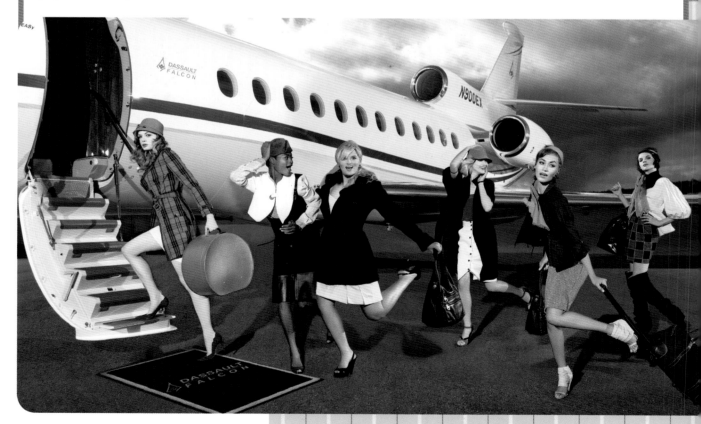

For any runway show, arrive alone backstage at least 30 minutes beforehand. It's inappropriate to bring anyone else backstage with you. Make sure you are clean and professional, and don't present any surprises or problems for the people running the show. Don't forget to pack your tote bag with everything you might need, and bring it with you backstage.

Backstage at a runway show can be very busy, so be considerate, and remain as calm and quiet as possible. Do not gossip or discuss the show or circumstances that arise during the show. Have an enthusiastic and receptive attitude toward any garment you're modeling to set the right mood.

Before the show begins, inspect the garments you'll be wearing to make sure everything is ready. Check the runway order, organize your garments and accessories so they're in the right sequence, and be aware of what other models you'll be following in each run. Open all of the zippers and buttons so you're able to change quickly.

While walking the runway, listen to the commentator, but do not look at the speaker. Concentrate on performing in character to the best of your ability, maintain eye contact with your audience, and work the clothes so that everyone is starstruck with your fierce style.

When the show is finished, place all the garments back on their hangers, and put all the accessories in their original boxes. Then gather your personal belongings and leave as quickly as possible.

You are responsible for reporting the completion of the assignment to your agency and submitting any vouchers you may have.

Fashion Weeks

Fashion weeks are publicity events that are set up to showcase designers' new lines for the next season. The designer pays for the show, including the clothing, venue, models, stylists, assistants, lighting, and music — all to create enormous exposure for themselves and their line.

The events are attended by buyers for stores, editors of fashion magazines, the media, critics, designers, celebrities, and socialites who can afford the designs. Fashion weeks are held twice a year in the major fashion capitals. Autumn/Winter collections are shown in January through March, and the Spring/Summer lines are usually presented in September through November. Each fashion week, the media and buyers preview the designs for the following season, and retailers rush to purchase or adapt their designs for their stores.

Fashion weeks used to be exclusively for the industry, but recently they've become entertainment events. They now often feature live musicians, celebrity guests, extravagant parties, or charity bashes, and a few even allow the public to purchase passes to see the runway shows.

Traditionally, the four fashion capitals are New York, Paris, London, and Milan. The shows in New York kick off each season, but recently dozens of fashion weeks have been held all over the world, including cities in India, Turkey, Colombia, South Africa, Iceland, Malaysia, Iran, Russia, and Australia, among others.

Some fashion weeks can be specific for certain types of garments, such as the swimwear week in Miami, prêt-a-porter (ready-to-wear) and couture weeks in Paris, bridal fashions week in New York, and the "green" design fashion week in Portland, Oregon.

If you're booked to model at a Fashion Week show, get ready for a thrilling but grueling experience in a fast-paced, hectic environment; dealing with insanely crowded backstage areas; quick clothing changes with no privacy; shoes that don't fit; and hurried, stressed stylists scraping your face and pulling out your hair. It's far from glamorous, but the exposure, excitement, and networking potential make it completely worthwhile.

New York Top Modeling Agencies

DNA
520 Broadway, 11th floor
New York, NY 10012
212-226-0080, ext. 4

Elite Model Management
404 Park Avenue South, 9th floor
New York, NY 10016
212-529-9700

Ford Models
111 Fifth Avenue
New York, NY 10003
212-219-6500

IMG Models
304 Park Avenue South, 12th floor
New York, NY 10010
212-253-8884

Marilyn Agency
32 Union Square East, penthouse
New York, NY 10003
212-260-6500

Next Models
15 Watts Street, 6th floor
New York, NY 10013
212-925-5100

One Management
42 Bond Street, 2nd floor
New York, NY 10012
212-431-0054

Wilhelmina
300 Park Avenue South
New York, NY 10010
212-473-0700

Woman Management New York
199 Lafayette Street, 7th floor
New York, NY 10012
212-966-3840

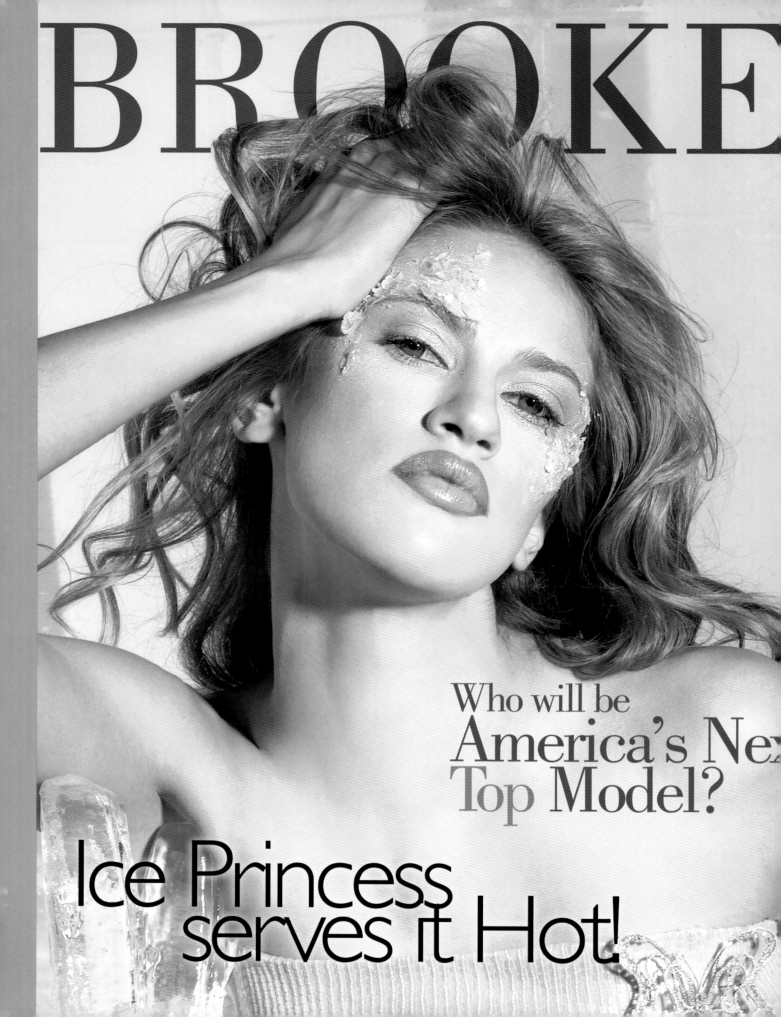

BROOKE

Who will be
America's Nex
Top Model?

Ice Princess
serves it Hot!

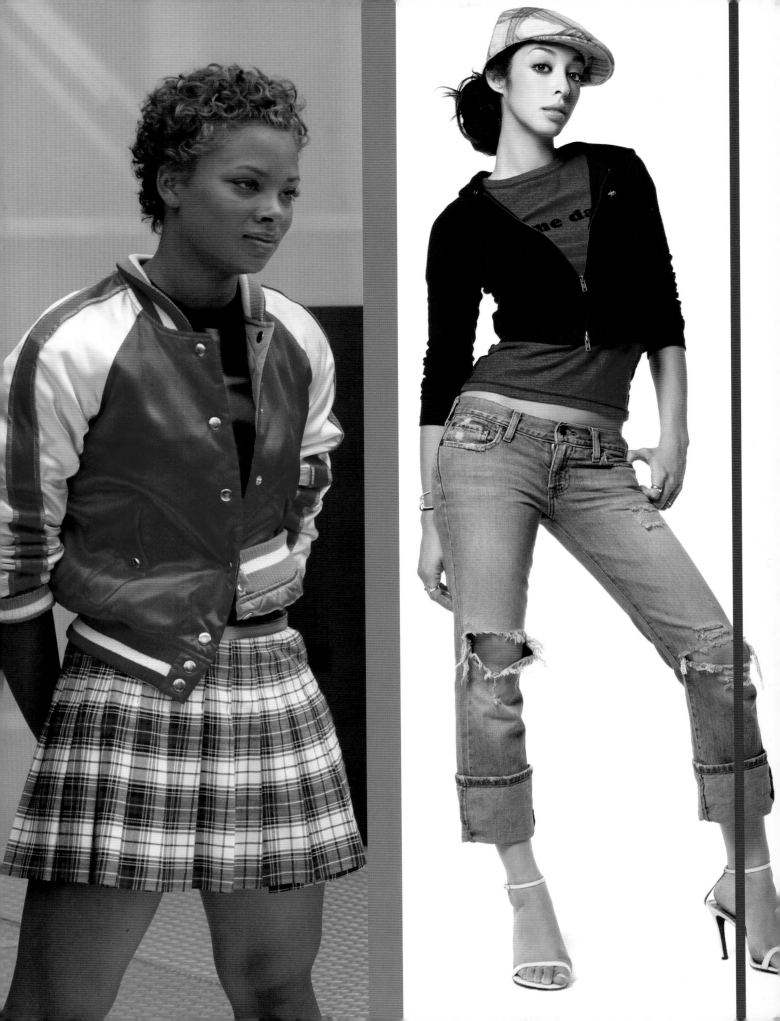

Many heartfelt thanks to...

Robb Pearlman for his editorial guidance, patience, and friendship; to Jennifer Laino for her flawless design; to Christian Marc for his excellent interview; to Hernán Echavarría-Sánchez for his understanding, encouragement, and support; and to Mabel and Gladys for their fierce inspiration.

Book, Web site, Article, and Television Show References

America's Next Top Model, Cycle 1–11. Executive producers: Ken Mok, Tyra Banks. 10 by 10 Entertainment, Pottle Productions, Ty Ty Baby Productions, Paramount (DVD), UPN, CW, 2003–2008.

Anastasia, Dorohova. "How Not to be a Fashion Model." *ModelPages.tv*, August 2008. www.modelpages.tv/how_not_to_be_a_fashion_model.asp.

Babauta, Leo. "9 Great Reasons to Drink Water, and How to Form the Water Habit." *Dumb Little Man: Tips for Life*, July 2007. www.dumblittleman.com/2007/07/9-great-reasons-to-drink-water-and-how.html.

"What Does It Take to Become a Successful Model." *Covergirl.co.uk*, August 2008. www.covergirl.co.uk/WEB/success.php.

Dean, Zero. "Advice for Models." *Zerotopia*, August 2007. www.zerotopia.com/resources/models/index.html.

Derrick, Julyne. "Beauty." *About.com*, May 2008. www.beauty.about.com.

Edelman, Joe. "Modeling Advice: Frequently Asked Questions and Articles." *Joe Edelman PhotoGraphics*, August 2008. www.joeedelman.com/faq/index.shtml.

References

Emling, Sherry. "Big 4 Fashion Weeks Get New Company." *International Herald Tribune,* October 2006. www.iht.com/articles/2006/10/03/features/Rweeks.php.

Esch, Natasha, and C. L. Walker. *Wilhelmina Guide to Modeling*. Fireside, 1996.

Ford, David. "Modeling and Pre-shoot Check Sheet." *David Ford Photography*, March 2008. www.davidfordphotography.com/shootinfo.html.

Fortini, Amanda. "How the Runway Took Off." *Slate*, February 2006. www.slate.com/id/2135561.

Gearhart, Susan Wood. *Opportunities in Beauty and Modeling Careers*. McGraw-Hill, 2004.

Goldberg, Joan Rachel. "Helping Yourself to a Good Night's Sleep." *National Sleep Foundation*. August 2008. www.sleepfoundation.org/site/c.huIXKjM0IxF/b.2421167/k.238/Helping_Yourself_to_a_Good_Nights_Sleep.htm.

"Lifestyle Lounge: Beauty and Fashion. "*Iloveindia.com*, August 2008. www.lifestyle.iloveindia.com/beauty-fashion.html.

"Are You Getting Your Beauty Sleep?" *Beauty & Style*, August 2008. www.beauty.ivillage.com/skinbody/facecare/0,,r11b,00.html.

Kritzeck, Katheryn. "How to Apply Makeup." *How2: A Thinker's Guide to Reality*, October 2003. www.calstaging.bemidjistate.edu/students/kkritzeck/howto.html.

Marcus Aaron. *How to Be a Successful Commercial Model: The Complete Commercial Modeling Handbook*. Marcus Institute of Commercial Modeling, 2008.

Mayes, Tom. "Model Tips and Information." *Tom Mayes Photography*, December 2003. www.tm-photo.com/portfolios/modinfo.htm.

MediLexicon International Ltd. "Health of Models on the Catwalks." *Medical News Today*, July 2007. www.medicalnewstoday.com/articles/76543.php.

References

Mindes, Nancy. "Relax and Release Your Inner Beauty." *Beauty Is Within*, February 2008. www.beautyiswithin.net/2008/02/relax-and-release-your-inner-beauty.html.

"Model Diet Tips and Advice." *Model Diet Plan*, August 2008. www.modeldietplan.com.

"What Is Model Attitude?" *Model Vanity for New Models*, February 2008. www.modelvanity.info/2008/02/what-is-model-attitude.html.

Munro, Paul. "Guide for a Modeling Career." *ModelWorker.com,* July 2008. www.modelworker.com.

International Modeling Guide, March 2006. www.myentertainmentworld.com/img/modeling_guide.html.

"Body Image." *National Eating Disorders Association*, August 2008. www.nationaleatingdisorders.org/p.asp?WebPage_ID=286&Profile_ID=41157.

Nellis, Cynthia. "Women's Fashion." *About.com,* August 2008. www.fashion.about.com.

Pardue, Bob. "Who Wants to Be a Female Photography Model?" *Bob Pardue Photography,* June 2008. www.bobpardue.com/articles/contents.htm.

Pawlik-Kienlen, Laurie. "A Former Model Gives Beauty Advice: 10 Ways to Enhance Your Physical Appeal from an Image Consultant." *Suite101.com,* June 2008.

www.psychology.suite101.com/article.cfm/beauty_advice_from_a_former_model.

Pegram, Billy. *Professional Model Portfolios: A Step-by-Step Guide for Photographers*. Amherst Media, Inc., 2004.

Press, Debbie. *Your Modeling Career: You Don't Have to Be a Superstar to Succeed*. Allworth Press, 2004.

Ranck, Rosemary. "The First Supermodel." *The New York Times*, February 1997. www.query.nytimes.com/gst/fullpage.html?res=9902E2DE153DF93AA35751C0A961958260.

"Fashion Style Tips for Women: Accessorizing." *Ribbonfree'sWeblog*, September 2007. www.ribbonfree.wordpress.com/2007/09/26/fashion-style-tips-for-women-accessorizing.

Rocchio, Christopher. "Whitney Thompson talks about her 'America's Next Top Model' win." *Reality TV World*, May 2008. www.realitytvworld.com/news/whitney-thompson-talks-about-her-america-next-top-model-win-7126.php.

Talley, Roger. "Welcome to Modeling 101." *NewModels.com*, June 2008. www.newmodels.com.

Tobey, Cheryl. *Choosing a Career as a Model*. Rosen Publishing Group, 2001.

Van Rossen, Daniel. *Modeling Advice*, June 2007. www.modelingadvice.com/Home.html.

UK Model Agencies. "Model Information." *UK Model Agencies*, August 2008. www.ukmodelagencies.co.uk/model-information-c19.html.

Williams, Roshumba, and Anne Marie O'Connor. *The Complete Idiot's Guide to Being a Model*, 2nd Edition. Alpha, 2007.